Greek Vases

Dyfri Williams

Published for the Trustees of the British Museum by
BRITISH MUSEUM PRESS

© 1985 The Trustees of the British Museum
4th impression 1992

ISBN 0 7141 2030 8

Published by
British Museum Press
A division of
British Museum Publications Ltd
46 Bloomsbury Street
London WC1B 3QQ

Designed by Roger Davies
Printed in Italy by New Interlitho

THE TRUSTEES OF THE BRITISH MUSEUM acknowledge with gratitude the generosity of THE HENRY MOORE FOUNDATION for the grant which made possible the publication of this book

Front cover Neck-*amphora* potted by Exekias and attributed to him as painter. Achilles kills Penthesilea, Queen of the Amazons. Made in Athens about 540 - 530 BC. Ht 41.6cm. *BM Cat. Vases* B 210.

Inside front cover Dionysos and satyrs: detail from the neck of a black-figured *amphora* signed by Andokides as potter and attributed to Psiax as painter (cf. 39a). Made in Athens about 530 – 520 BC. Ht of figures 7.0cm. GR 1980. 10 – 29.1.

Title page Plate painted by Epiktetos showing two revellers, made in Athens about 520 - 510 BC. Diam. 18.8cm. *BM Cat. Vases* E 137.

This page View of Athens from the south west in about 1810. A watercolour by William Gell (1777 - 1836). Lord Byron dubbed this prolific artist 'Rapid Gell'.

Inside back cover Etruscan dish showing a young hunter and his dog, probably made in southern Etruria in the early third century BC. Diam. 18.5cm. *BM Cat. Vases* F 542.

Back Cover Oinochoe attributed to the Brygos Painter, depicting a woman spinning. Made in Athens about 490 - 480 BC. Ht 22.3cm. *BM Cat. Vases* D 13

Contents

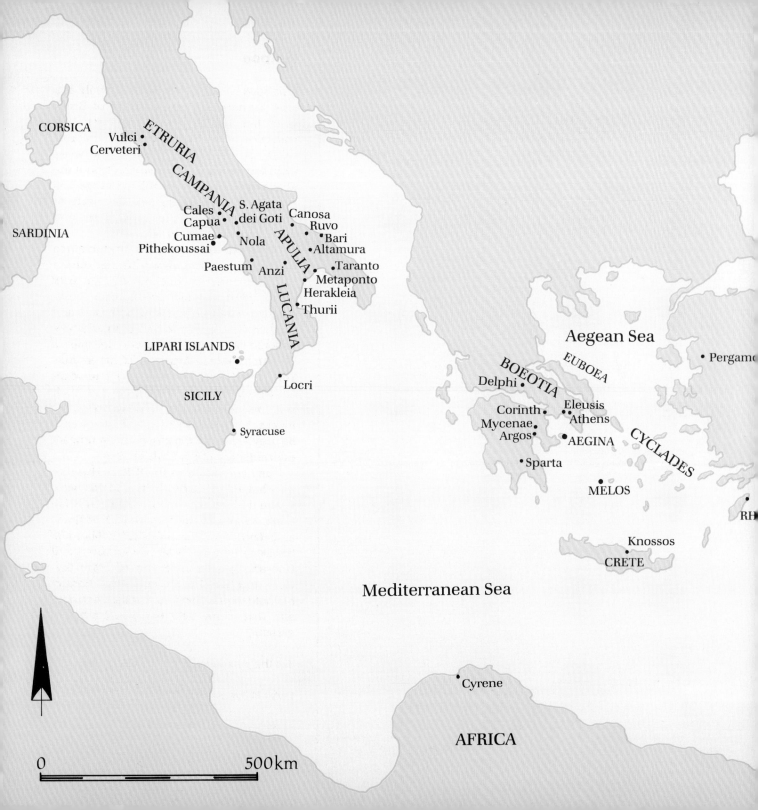

CORSICA

ETRURIA

Vulci
Cerveteri

CAMPANIA

SARDINIA

Cales
Capua

Cumae
Pithekoussai

S. Agata
dei Goti

Canosa
Ruvo
Bari

Nola

APULIA

Altamura

Paestum
Anzi

Taranto

Metaponto

LUCANIA

Herakleia

Thurii

LIPARI ISLANDS

Locri

SICILY

Syracuse

Aegean Sea

EUBOEA

BOEOTIA

Delphi

Corinth
Mycenae
Argos

Eleusis
Athens

AEGINA

CYCLADES

Pergamo

Sparta

MELOS

RH

Knossos

CRETE

Mediterranean Sea

Cyrene

AFRICA

0 500km

CRIMEA • Kerch

Black Sea

ASIA MINOR

SYRIA

CYPRUS

EGYPT
…dria •
…ukratis •

Preface

This book is intended to serve not only as a brief introduction to the world of Greek vases but also as a select guide to the collection of the British Museum. Unfortunately, at the time of writing, the vases included here are sadly scattered about the Museum; some are even still in storage. It is hoped, however, in the next few years to make all the vases illustrated here, and many more, visible to all.

As is usual with a general introduction to a subject, this work draws heavily on the studies of other scholars, not least the work of Sir John Beazley on Athenian vase-painters. To these scholars, both past and present, I am deeply indebted. In addition, I should like to thank Dr D. von Bothmer of The Metropolitan Museum of Art in New York and Dr M. Maass of the Badisches Landesmuseum in Karlsruhe for their generous co-operation in reassembling the Brygos Tomb in London forty years after Beazley's study of the group and in time for the centenary of his birth in 1985.

Many colleagues in the British Museum have helped in the production of this book. I should like to mention in particular Brian Cook, Keeper of the Department of Greek and Roman Antiquities, Nigel Williams of the Department of Scientific Research and Conservation, Susan Burch of Office Services, and Ivor Kerslake and James Hendry of Photographic Services. For their support, and that of my wife Korinna, I am very grateful.

To the memory of my mother, Eira.

Dyfri Williams May 1984

5

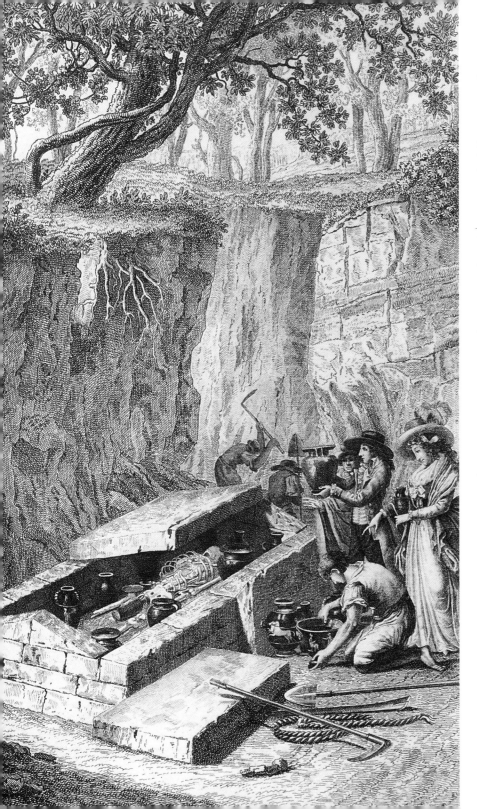

Introduction

The making of pottery from fired clay was the most widespread of all the crafts in ancient times. Every manner of shape could be made and all kinds of functions fulfilled. Both wet and dry materials could be stored in pottery vessels, cooking could be done in them and people could eat and drink from them. Moreover, since the Greeks, like many ancient peoples, not only used pottery but treasured it, it is to be found in sanctuaries and in tombs, as well as in domestic contexts. The only drawback for the owner of pottery, then as now, is its breakability. This is, however, to the advantage of the archaeologist, for pottery is, as a result, the most frequently excavated material on ancient sites.

The pottery found in tombs is usually complete, but not always intact, that from settlements and sanctuaries is regularly reduced to isolated fragments. Yet even a small fragment is of interest to an archaeologist, for from a careful study of its decoration and shape he can estimate its date and, therefore, that of the context in which it is found. The importance of ancient Greek vases, however, goes beyond the regular uses to which pottery is put by the archaeologist, for one of their most remarkable features is that they are often decorated with scenes involving human figures, which can provide valuable insights into ancient Greek customs, beliefs and even fantasies. Finally, Greek vases can frequently be appreciated just for their sheer beauty of form and decoration.

1 Sir William Hamilton and Emma (?) opening a tomb at Nola. An engraving from a watercolour by C.H. Kniep, 1790, frontispiece of W. Tischbein, *Collection of Engravings from Ancient Vases... in the Possession of Sir Wm. Hamilton* (Naples 1791).

1
Making and Painting a Greek Vase

Kritias, the late fifth-century Athenian poet and politician, claimed that it was Athens 'that invented the potter's wheel and the offspring of clay and kiln, pottery so famous and useful about the house'. Although this claim is probably not true, Athenian clay was one of the finest Greek clays by reason of its excellent working characteristics and its warm orangey-red colour, and it was at Athens that the art of pottery reached its peak. We shall, therefore, anticipate some of the early history of Greek pottery and concentrate first on the technique of Athenian pottery-making and painting.

Clay is essentially weathered rock. Sometimes it is found in its original location, undisturbed, in which case it is called 'primary' clay and is extremely pure. More often in the Mediterranean, however, it has been moved from its original position by glacial action or erosion and deposited elsewhere, together with impurities which may colour it. This is 'secondary' clay. Around Athens the plentiful clay beds are rich in iron and the clay they produce turns an orangey-red when fired. A hill on the island of Aegina, close to Athens, however, is made up of a 'secondary' clay with intrusive sea shells which fires to a yellowish green. The colour of clays and their different impurities enable us to distinguish between their various places of origin.

Clay, as it is dug out, is full of foreign bodies which must be removed before it can be used. This was done in ancient times, as it is today, by mixing the clay with water and letting the heavier impurities sink to the bottom. This process of settling ('levigation' or 'elutriation') could be carried out as many times as were necessary in order to obtain the right degree of purity for the form of vessel required.

After the clay was sufficiently purified and the required amount kneaded and prepared (clays might even be mixed), it would be centred on the wheel and drawn up by the potter's deft fingers into whatever shape was desired. The finished vessel was usually made up of separate pieces — feet, handles and spouts. Even the body itself, if it was over 30 cm high, might also be made in sections, for clay has a tendency to slump above such a height. These sections and pieces were dried for about twelve hours and then joined together using a clay slip as a glue. On the inside of a rather rough Athenian cup we see a potter applying the handle to the cup which stands before him on his wheel. Above, on a shelf, sit some of his finished products (four cups and what looks like a jug), probably drying out before being decorated. Below the potter's feet his dog patiently waits for the end of the day.

After potting came the decoration. Some preliminary sketching was often done before the final painting, but whatever sub-

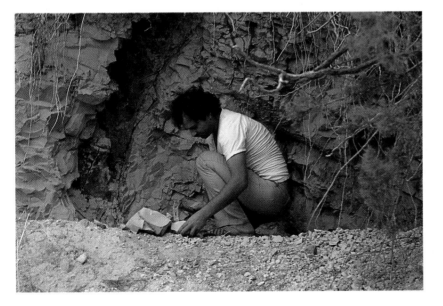

2 Dimitris Garis digging out clay on a hill near Mesagros on the island of Aegina. He uses a small pick to cut it out and examine it. (Author's photo.)

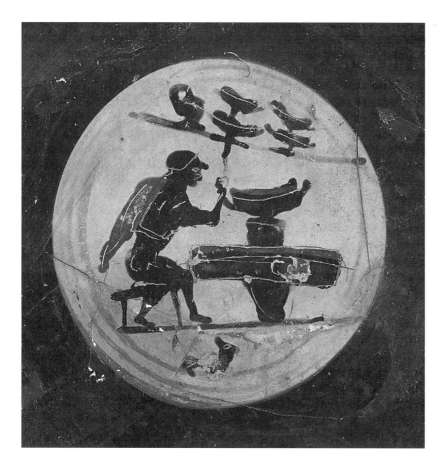

3 A potter adding the handle to a cup that stands on his wheel. Interior of a cup made in Athens about 490 BC. Diam. of tondo 6.3cm. *BM Cat. Vases* B 432.

slip, usually called black glaze, consisted, at Athens, of a more finely purified, almost concentrated, form of the regular clay which by an ingenious firing process turned black in the kiln, in contrast to the orangey-red body. Additional colours were also used, especially from the seventh century BC onwards. The two most common of these are a purplish red and a yellowish white, both with a matt surface. The purplish red was produced by mixing red iron oxide pigment (ochre) with water and the normal black slip matter. The white was simply a very pure, 'primary' clay with almost no iron oxide present as an impurity to colour it on firing. These two colours were fired on in the kiln, but occasionally, at certain times and under certain circumstances, colours were added after firing. These were more fugitive, mineral or vegetable colours that would burn off at the temperatures used in the kiln and they included blues, greens, pinks and other matt colours.

The application of these slips and colours was usually done with brushes. Sometimes, however, the lines have a real three-dimensional quality, especially the so-called 'relief line' of the red-figure technique, which has led to a number of suggestions concerning both the implement used and the technique employed — a quill, a bag with a nozzle for extruding the clay like a piping-bag for icing a cake, and a hair or group of hairs laid on the surface and then lifted off. Examination of the form of such lines and how they behave seems to indicate, however, that even these 'relief lines' were made with a brush, probably a brush with long, thin bristles, rather like a modern day 'rigger' brush used for doing the rigging in oil-paintings of ships. For this sort of line, however, the consistency of the slip must have been particularly thick. In

stance was used cannot be determined since it was burnt off during the firing of the vessel in the kiln. The most we can see is a very faint indentation in the surface of the vase, and even this only occurs when the sketch was made before the vase was properly dry. The painting itself was, in fact, done neither with paint nor with glaze, although these terms are often the most convenient. The materials that Athenian potters used to decorate their vessels were nothing more than specially prepared clays. The key colour is the shiny black, which contrasts so well with the warm orangey colour of the fired clay. The black

4 ·

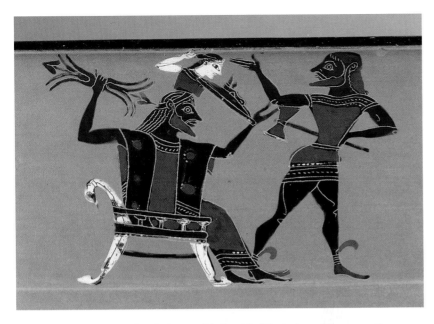

4 Athena is born from the head of Zeus with the aid of Hephaistos. Athena was the patroness of ancient craftsmen, including potters and painters. Detail from the lip of a cup attributed to the Phrynos Painter, made in Athens about 540 BC. Ht of figures 4cm. *BM Cat. Vases* B 424.

5 Diagram of a kiln, adapted from A. Winter, *Die Antike Glanztonkeramik* (Mainz 1978) p.28 (drawing by Susan Bird):
1) stoking tunnel; 2) firing chamber; 3) central post; 4) pierced floor; 5) stacking chamber; 6) spy-hole and hatch; 7) removeable section of wall to enable loading; 8) vent hole; 9) cover for stoking tunnel.

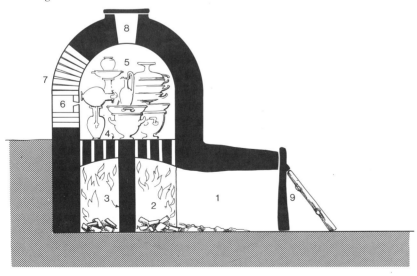

contrast, we also see thin, golden-brown lines which are a result of deliberately diluting the slip ('dilute glaze lines').

Let us now consider the ingenious firing process that turned the body of a Greek vase red but made the slipped or painted parts black. Unlike modern pottery, ancient Greek pottery was only fired once, but that single firing had three stages. First, the vases were stacked in the upper chamber of the kiln. They were nested one inside another or balanced one on top of each other, and there is sometimes a reddish ring around the wall of a cup or on the side of a larger vase where such stacking has resulted in a slightly irregular temperature at the point of contact. In due course the fire was lit and the kiln heated up to about 800°C under oxidizing conditions, that is with free access of air. During this first stage the vases in the kiln turned red all over. After the temperature had reached 800°C the atmosphere was changed to a reducing one by introducing green wood into the firing chamber and closing the air vents. While this reducing atmosphere was maintained, the temperature was raised to around 950°C and then allowed to cool down to about 900°C. During this second stage the vessels turned all black. There then followed the third and final stage of the firing process: the vents were opened and the atmosphere returned to an oxidizing one, as the kiln was allowed to cool completely. In this final stage the body of the vase turned red again, but the areas painted with black slip remained a glossy black.

This division in colour and texture is caused by the partial vitrification or sintering of the surface of the slipped areas at the moment of highest temperature in the second stage, a sealing of the surface which prevents the re-entry of oxygen and the

subsequent return to the red colour in the final stage. If by chance the temperature was raised too high in the third phase, say to 1050°C, the oxygen would re-enter and the slipped areas go red again. The successful three-stage firing of an Athenian vase was, therefore, dependent on a precise control of both the atmosphere in the kiln and the temperature. This control was achieved by the use of test or draw pieces inserted through the hatch in the side of the domed kiln, and by experienced observation of the colours to be glimpsed through the spy-hole.

There were, however, many things that could go wrong in the kiln and ancient potters seem to have been very superstitious, fearing all sorts of special demons with names like 'Smasher', 'Crasher' and 'Shaker'. Pottery-making was a hard and demanding craft; indeed a popular ancient idiom for 'to work hard' was 'to make pottery'. It was, moreover, a craft that required a great deal of skill and experience. We find, therefore, not only that some ancient potters were slaves but also that the craft was passed from father to son. In one representation of a potter's workshop a woman helps with the painting, suggesting that in some establishments the whole family might be enlisted. Dimitris Garis, shown collecting clay near Mesagros on Aegina, is himself a fifth-generation potter and works with his mother and wife.

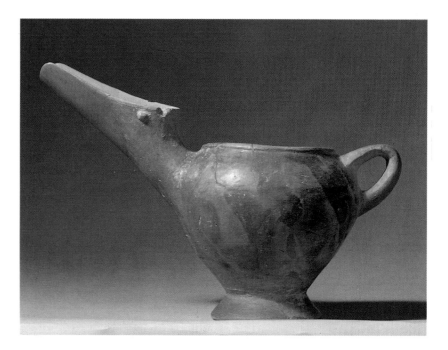

6 *Right above* Early Bronze Age Vasiliki Ware 'tea-pot' with mottled decoration, made on Crete about 2500 – 2200 BC. Ht of body 12.1cm. *BM Cat. Vases* A 425.

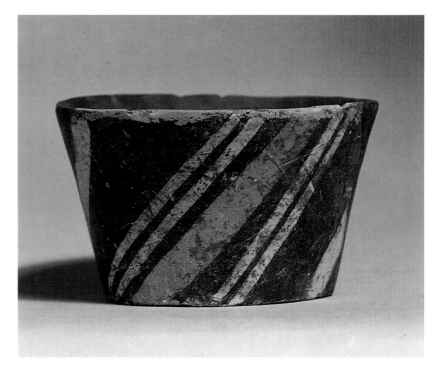

7 *Right below* Middle Bronze Age Kamares Ware cup (handle missing), made on Crete about 2000 – 1900 BC. Ht 4.5cm. *BM Cat. Vases* A 477.

2
From 6000 BC
to 1000 BC

The earliest pottery from the Greek peninsula goes back to about 6000 BC (the Early Neolithic period) and was perhaps introduced by a wave of immigrants from the Near East, where pottery-making is first attested in about 8000 BC. At first this hand-made pottery was plain, its shapes simple and functional. Three types of decoration eventually developed: simple incisions, impressed or relief designs and, when potters could consistently produce a smooth surface, some painted patterns were also attempted. The paint used on these early vases was normally of a mineral composition which, when subjected to a single-stage firing, turned a matt black or brown. It was only in the fifth millennium BC (Middle Neolithic) that a dark brown lustrous wash was applied to some vases from southern Greece; this was in time to

develop into the wonderful glossy black slip or glaze so typical of later Athenian pottery.

On Crete, the most southerly Greek island, which was to play an important role in the early history of the Greek world, an unusual type of pottery occured in the early third millennium BC (Early Bronze Age): it is called 'Vasiliki Ware' after a settlement in eastern Crete where it was first discovered. Here, the vase has been given a lustrous reddish-brown wash and the surface mottled with large darker spots. This rather attractive effect, perhaps intended to imitate the variegated stone vases that were then fashionable, may have been achieved in various ways, perhaps even by an early form of the three-stage firing process. The peculiar shape, nowadays called a 'teapot', is of eastern origin.

8 *Below left* Middle Bronze Age Grey Burnished Ware cup (upper part restored), made on the Greek mainland about 2000 – 1500 BC. Restored ht 19cm. *BM Cat. Vases* A 284.

9 *Below right* Middle Bronze Age Matt-Painted jug. Made in the Cyclades about 1850 – 1700 BC. Ht 39.8cm. *BM Cat. Vases* A 342.

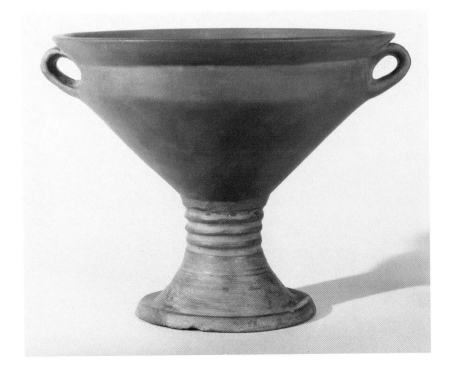

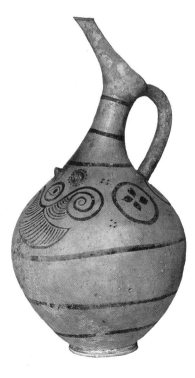

The two tiny pellets added near the rim of the spout give the whole vessel an amusing, bird-like appearance.

Some time around 2000 BC (Middle Bronze Age) a fast-rotating wheel was finally developed in the Greek world. This wheel, which might be made of wood, fired clay or stone, was turned by an assistant (with a stick or by hand), thus leaving the potter free to work the clay with both hands. The results of this radical advance in technology differed on Crete and on the mainland. On Crete the potters produced an eggshell-thin ware (known as Kamares Ware) in imitation of metal vessels, decorated with white and red paints, and sometimes even a yellow, on a glossy black ground. Designs were vivid and well related to the shapes on which they occurred, as is shown even by a modest cup. On the mainland, however, the fast wheel brought added sharpness to the elaborately turned profiles of the plain burnished or polished ware, which had now become the standard pottery.

Alongside this plain, metallic-looking wheel-made pottery there arose on the mainland around 1900 BC a hand-made dark-on-light ware decorated with a matt paint on a buff-coloured surface. This rather retrogressive step was perhaps the result of further migrations from the East: indeed, we see the idea pass through the Cyclades to the island of Aegina, where clay like that from Garis's hill was used, and finally to the mainland. The most imaginative use of the technique, however, continued to be in the Cyclades, as a fine jug from Melos demonstrates. Here we see how the potter has turned a simple narrow-necked jug into something both elegant and remarkably human by tilting the neck back, adding a pair of small breasts to the upper body and painting in the midst

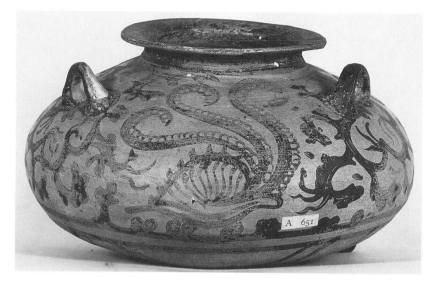

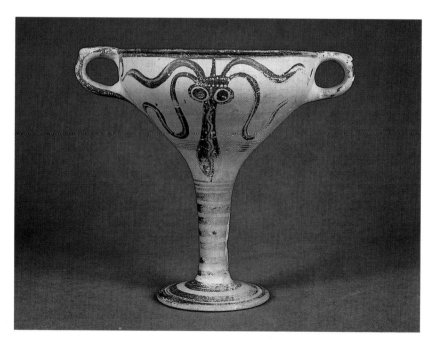

10 *Top* Late Bronze Age Marine Style flat *alabastron* with an argonaut in a rocky seascape. Made on the Greek mainland about 1500 – 1450 BC. Ht 11.5cm. *BM Cat. Vases* A 651.

11 *Above* Late Bronze Age high-stemmed cup with a stylized octopus (or cuttlefish), made on the Greek mainland about 1350 – 1300 BC. Ht 21cm. *BM Cat. Vases* A 870.

of an abstract, moustache-like pattern a single human eye.

The first half of the second millenniun BC saw the rise of great palaces on the island of Crete and considerable Cretan influence on mainland Greece. It is noticeable that as prosperity increased and more vessels of precious metal became available, so a decline in the potter's art seems to have occurred. Yet alongside this decline there was also an increase in interest in naturalistic decoration, probably as a result of influence from the flourishing art of large-scale wall-painting. Some of these vases showed flowers and plants, but at Knossos in central Crete between about 1500 BC and 1450 BC a group of potters were producing special vases, probably for ritual use, that were decorated with marine motifs — octopuses and argonauts amid rocks and seaweed. These vases were widely exported and even imitated on the Greek mainland.

On the mainland the matt-painted ware had begun to be replaced by lustrous painted vessels around 1500 BC (Late Bronze Age), and this marks the beginning of the so-called Mycenaean period. The technique of decoration, like the new motifs, was no doubt borrowed from Crete – the mainland was now, indeed, beginning to look outwards more and more, witness our 'Marine Style' flat *alabastron* (jar), which was found in Egypt. As a series of catastrophes hit the southern Aegean and Crete, perhaps triggered by the volcanic eruption of the island of Thera, the mainland Greeks stepped into the breach and seem to have taken control of Knossos and perhaps much of the rest of the island. The inevitable effect on the pottery was a convergence of styles: on Crete we see at first large impressive vases with grandiose yet stiff decoration, but during the four-

teenth century there was increasing simplification and standardization throughout the Aegean, as political control began to centre on the city of Mycenae itself. By 1300 BC archaeologists speak of a *koine* or 'common style' and its vases are to be found over much of the Aegean.

The potting of these late Mycenaean vases is often very fine, with clean-lined shapes. Decorative motifs were still ultimately derived from fifteenth-century Cretan plant and marine designs, but all was now stylized and often rather stiff. The best of both potting and painting is to be seen on a high-stemmed cup from the island of Rhodes in the eastern Aegean. A fine octopus, stylized until it suits the shape perfectly, dominates the whole vase.

Rather different, however, is a series of large *kraters* (mixing bowls), some of which show figures in chariots. This is the first sustained use of human figures on the pottery of Greece; the idea was probably culled from wall-painting, a medium in which the depiction of men and women was clearly felt to be more appropriate. On a small *krater* we see a chariot and what seems to be an archer loosely disposed across the upper frieze. There is little or no finesse to the painting and the figures are nothing more than a pale reflection of even the frescoes produced on the mainland.

Around 1200 BC the palaces on the Greek mainland were destroyed, never to be rebuilt. As a result of these upheavals the uniform Mycenaean pottery style began to fragment into a number of local styles. Soon there followed a decline in the repertoire of designs. A fairly typical Sub-Mycenaean vase, as the style is called, is a small and distinctly unpretentious belly-handled *amphora* on which the decoration has been reduced to a pair of wavy lines. lines.

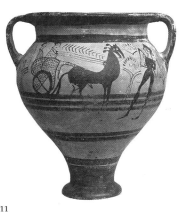

12 *Top* Late Bronze Age *krater* with chariot and archer, made on the Greek mainland about 1350 – 1300 BC. Ht 25.8cm. *BM Cat. Vases* C 341.

13 *Above* Sub-Mycenaean belly-handled *amphora*, made in Athens about 1100 – 1050 BC. Ht 10.8cm. *BM Cat. Vases* A 1093.

After a period of depression, the Greek people and their potters began to look abroad again and in due course a new beginning was made. This renaissance began at Athens around the middle of the eleventh century BC and is marked by the appearance of so-called 'Protogeometric' pottery. Vases are once again made on a fast wheel, shapes firm up and the paint becomes more lustrous as a result of higher firing temperatures. In addition to these advances in potting the decoration becomes more careful and better suited to the shapes.

16a A fine belly-handled *amphora* (storage jar) shows both old and new. The shape is of Mycenaean derivation, as is the triple wavy-line decoration, although the way it is set in a panel and framed by zigzag stitch-like lines has not been seen before. The increase in the amount of dark lustrous paint is also typical of the new Pro-
16b togeometric style. By contrast, a neck-handled *amphora* retains the light-ground effect of its Mycenaean predecessors, but also shows one of the new motifs invented by the Athenian potters: concentric circles painted with a multiple brush attached to a compass. Other areas of Greece quickly imitated these Athenian advances, but their versions never really reached the same level of achievement and as a result Athenian Protogeometric vases were welcomed in many parts of Greece, including Crete.

The technical excellence of Athenian pottery and its harmony of shape and decoration are maintained in the ninth century BC, when Protogeometric develops into Geometric. A jug in the British
14 Museum from the beginning of the ninth century (Early Geometric I) shows the transition very well: the black glaze now dominates completely; only a narrow band

14 *Right above* Early Geometric *oinochoe*, made in Athens 900 – 850 BC. Ht 29.9cm. GR 1950.2 – 28.2.

15 *Right below* Middle Geometric *pyxis* with a handle in the form of another *pyxis*, made in Athens about 850 – 800 BC. Ht 18.6cm. GR 1913.11 – 13.2.

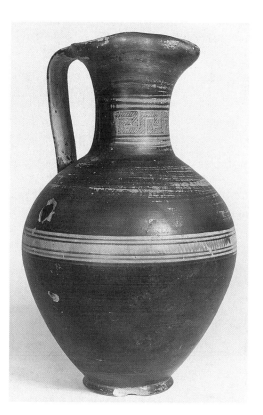

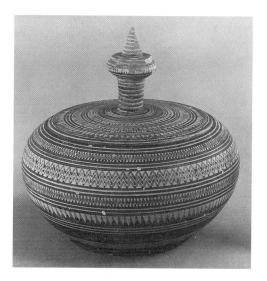

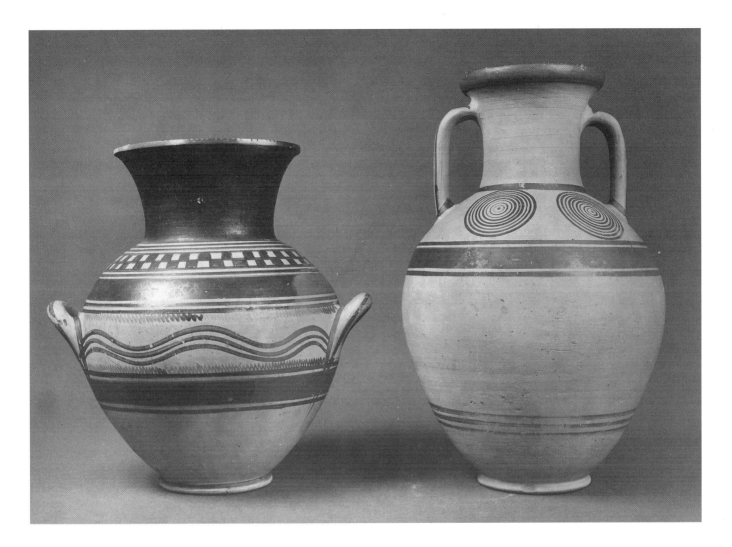

16a Protogeometric belly-handled *amphora* (left), made in Athens about 1050 – 900 BC. Ht 35cm. *BM Cat. Vases* A 1123. (**b**) Protogeometric neck-handled *amphora* (right), made in Athens about 1050 – 900 BC. Ht 43.4cm. *BM Cat. Vases* A 1124.

of stitch-like zigzag alleviates the darkness. The neck, however, carries one of the new motifs taken up by the potters at this time, the 'maeander' or key-pattern. This is perhaps the most characteristic pattern of the Geometric period.

A smaller vase, a circular toilet box, or *pyxis*, with lid, takes us into the second half of the ninth century BC (Middle Geometric I). It is a new shape that appears at this time and becomes standard for the

Geometric period: indeed, the *pyxis* is a common gift both in tombs and in sanctuaries. The amount of decoration increases considerably during this period, and the black, so beloved of earlier generations, is driven back by the enthusiasm for new geometric patterns. On this example the knobbed handle takes the form of a second, miniature *pyxis* – a conceit much enjoyed by Greek potters of the time.

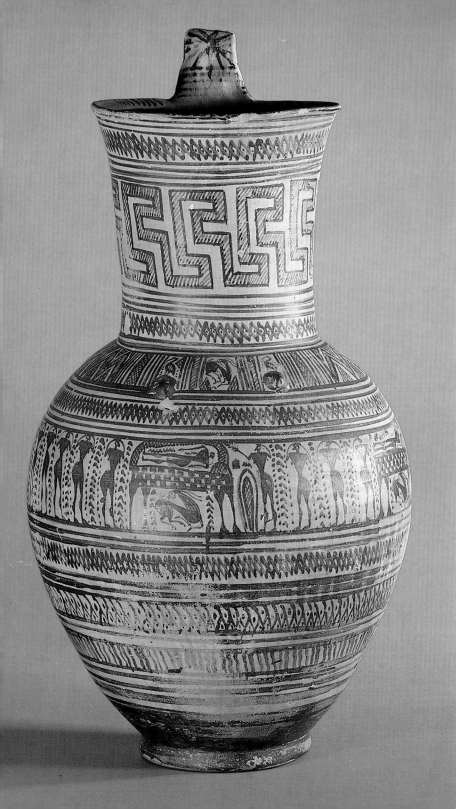

The next major step in the story was taken around 770 BC when, quite suddenly, ambitious figured scenes occurred (isolated animals and humans had occasionally appeared since the tenth century BC). Subjects include fights on land and sea, processions of warriors and chariots, and ceremonies concerned with the dead. The latter theme is particularly appropriate, for many of these vases were placed in tombs — the larger pieces sometimes serving as grave-markers above ground.

On a large jug (or pitcher) dating from the last quarter of the eighth century BC (Late Geometric II) we see rows of women, hands to their heads in the ritual gesture of mourning, surrounding a bier on which a corpse is laid out under a shroud. The drawing is essentially conceptual — the artist draws what he knows is there, rather than what he can actually see. Each part of the body is given its most diagnostic view — head in profile, chest frontal and triangular (the female breasts project from the sides), and legs in profile with prominent buttocks and calves. These schematic silhouettes seem to mark a new beginning for figure-painting in Greece, but they do not necessarily represent the first naive attempts of an artist who had never seen figure-painting before, for new excavations are continually providing evidence of contacts with cultures that retained a tradition of representing figures in a variety of media.

In addition to the representation of the *prothesis* (the laying-out of the dead), which is unexpectedly repeated four times on this pitcher, there are a number of animal motifs. A goat is depicted under the bier and a second smaller specimen appears in the central panel in the frieze above, while a bird perches on each of the

17

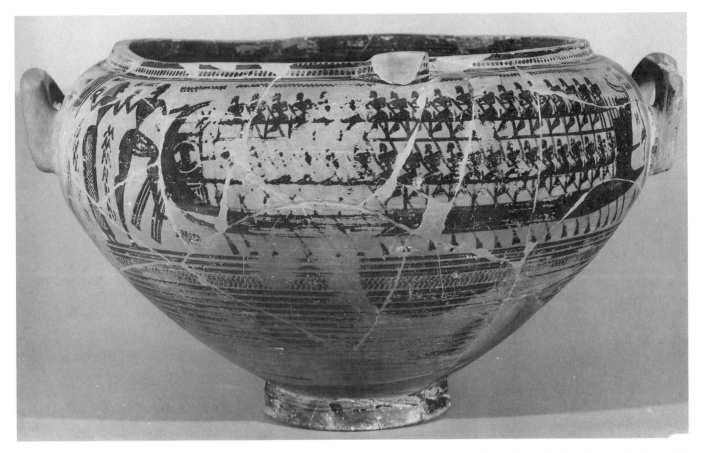

18 *Above* Late Geometric spouted *krater* with a many-oared warship. Made in Athens about 730 – 720 BC. Ht 30.9cm. GR 1899.2 –19.1.

17 *Left* Late Geometric pitcher showing mourners at the laying-out of the dead. Made in Athens about 720 – 700 BC. Ht 44.3cm. GR 1912.5 – 22.1.

18

miniature nipples added in relief. There is too, of course, a wealth of subsidiary geometric ornament, especially the tall stepped-maeander, which dominates the neck of the vase.

Occasionally scenes that suggest mythological subjects are to be found. For example, on a large spouted *krater* is a remarkable representation of a mighty oared ship, filled with oarsmen poised for the command to pull. A man is about to board, but as he does so he grips the wrist of a woman, who stands behind him. This may be Paris abducting Helen, or Theseus carrying off Ariadne, or even Odysseus bidding farewell to his wife Penelope. Such ambiguity is typical of the scenes on Late Geometric vases that appear to be mythological: the artists seem reluctant to break with the generalized approach to narrative that they had developed. With the seventh century, however, such barriers are broken down and mythological scenes can be more explicit.

Many other Greek city-states and regions produced Geometric pottery – Argos, Corinth, Boeotia, the Cyclades and the Greek cities along the coast of Asia Minor. None, however, was as widely exported and none had such a prolific figured style

as that of Athens. Indeed, one of the schools most resistant to figured decoration was that of Corinth. Here simple linear decoration predominated, emphasizing the extremely fine potting that her craftsmen were able to achieve. A group of three vases, which date from around 700 BC or soon after and are said to come from a single tomb at Cumae in central Italy, show both these characteristics admirably. Although their potting and the style of their decoration suggest that all three were made by Corinthians, only the deep cup (*kotyle*) was actually made at Corinth. The redder clay of the round scent-bottle (*aryballos*) and the flat-bottomed oil-jug (*oinochoe* – this vase is now in Oxford) reveals that they were made on the island of Pithekoussai just off the coast of Italy, opposite Cumae, despite the addition of a pale slip intended to make them look like authentic Corinthian products. The island of Pithekoussai was the first Greek colony in the West, founded by Euboean adventur-

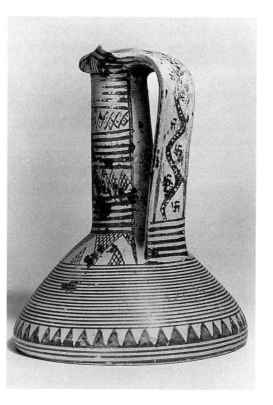

20 Early Protocorinthian conical *oinochoe* said to be from the same tomb at Cumae as the vases in **19**. Made on Pithekoussai about 700 – 690 BC. Ht 14.4cm. Oxford 1937.697 (photo courtesy of the Ashmolean Museum).

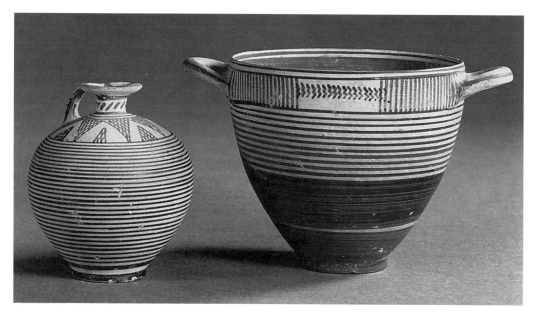

19a Early Protocorinthian *aryballos* (left), made on Pithekoussai about 700 – 690 BC. Ht 7.5cm. GR 1950.1 – 24.2. (**b**) Early Protocorinthian *kotyle* (right), made in Corinth about 700 – 690 BC. Ht 8.5cm. GR 1950.1 – 24.1.

21 *Right* (**a**) Early Protocorinthian *aryballos* with warrior and squire (left), made in Corinth about 690 BC. Ht 6.8cm. GR 1969.12 – 15.1. (**b**) Late Protocorinthian *aryballos* (right), made in Corinth about 650 BC. Ht 12.8cm. GR 1860.4 – 4.16.

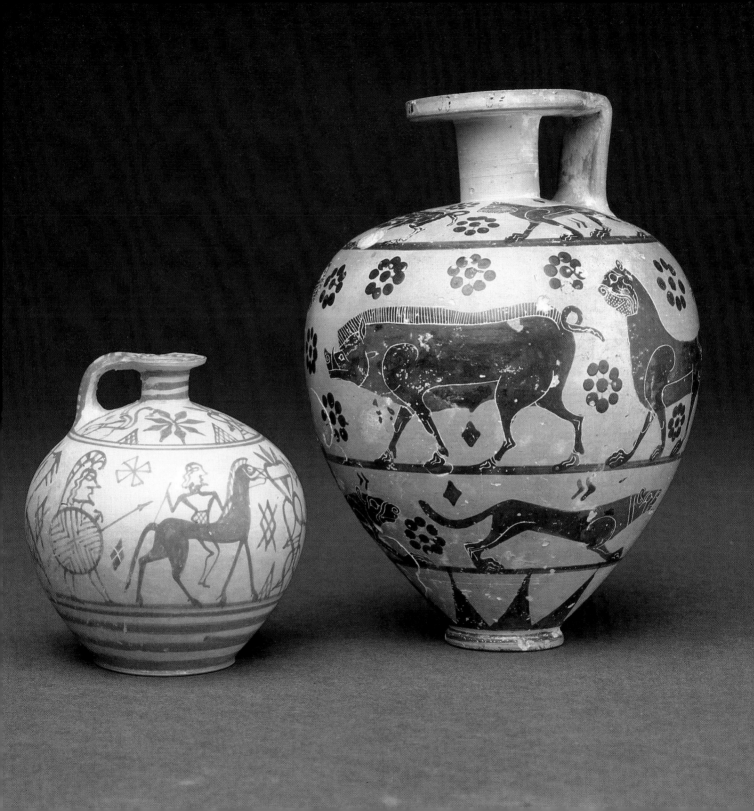

ers, but once it was firmly established there seems to have been a move to settle on the mainland at Cumae. At about the same time a number of Corinthian potters arrived, perhaps to gain closer access to the new markets in Italy.

Protocorinthian pottery, as we call Corinthian pottery in the earlier seventh century BC, was now becoming a popular export item, especially the small *aryballoi*. This extra demand, together perhaps with new overseas contacts, caused changes in Corinthian vase-painting. Suddenly the domination of linear decoration was broken and both figures and new oriental-looking motifs were introduced. On a small 21a rounded *aryballos*, dating from the beginning of the seventh century (Early Protocorinthian), we find, in addition to some animals, two piratical-looking figures, one a warrior with shield, helmet, spear and sword, the other a figure on horseback. In the field are new decorative patterns, some strongly curvilinear, especially that just beyond the horse. Most of the drawing is done in outline in contrast to the traditional Geometric silhouettes, but there is also the tentative use of a new idea, that of scratching with a fine point through the black slip to the pale clay below. It can be seen on the diamond between the two figures and, on the other side of the vase, on the dappled skin of a stag. This technique of incising details with a point is known in bronze working and in ivory carving, both of which arts flourished in Corinth at this time, and its use by vase-painters may have been borrowed from their fellow craftsmen. From its use on vases like this *aryballos* however, it seems that the technique was first employed to facilitate the making of fine markings on dark areas – only gradually did artists realise its full potential.

This technique of incision came to fruition towards the middle of the seventh century BC, when it was used for all interior markings of the silhouettes and a purplish red was added to highlight certain areas – this is the so-called 'black-figure' technique. On a larger than normal *aryballos* 21b from about 650 BC (Late Protocorinthian), found in a tomb on Rhodes, we see three friezes of animals, including lions, dogs, boars and a bull. The painting is superbly sharp; the animals are proud, kingly creatures. The precise dot-rosette filling ornaments are typical of Protocorinthian vase-painting, while the rays around the base first occur in the seventh century under oriental influence.

Besides friezes of animals executed in the wonderful miniaturist style that is the glory of Protocorinthian vase-painting we occasionally meet mythological scenes, especially those centering on Herakles, but on the most elaborate pieces we find complex battle scenes that do not seem to have specific mythological settings. Thus, into the main frieze of a remarkable *arybal-* 22 *los* only 6.8 cm tall, are packed seventeen struggling warriors, pushing and thrusting with their spears, their shields decked with vivid blazons. This piece, and the other similarly complex fight scenes, belongs to a time in Corinth's history when a long-established aristocracy was suddenly replaced by a tyranny, and when a new method of fighting began to gain widespread acceptance. This method involved lines of heavily armed infantry (*hoplites*) fighting, as the seventh-century poet Tyrtaeus described it, 'foot to foot, shield to shield, crest to crest, helmet to helmet, chest to chest, grasping your sword or long spear'. Such battle scenes on vases may perhaps reflect this period of violence and change.

22 *Right* Late Protocorinthian *aryballos* with lion's head spout and three decorative friezes: a fight, a horse-race and a hare-hunt. Made in Corinth about 640 BC. Ht 6.8cm. GR 1889.4 – 18.1.

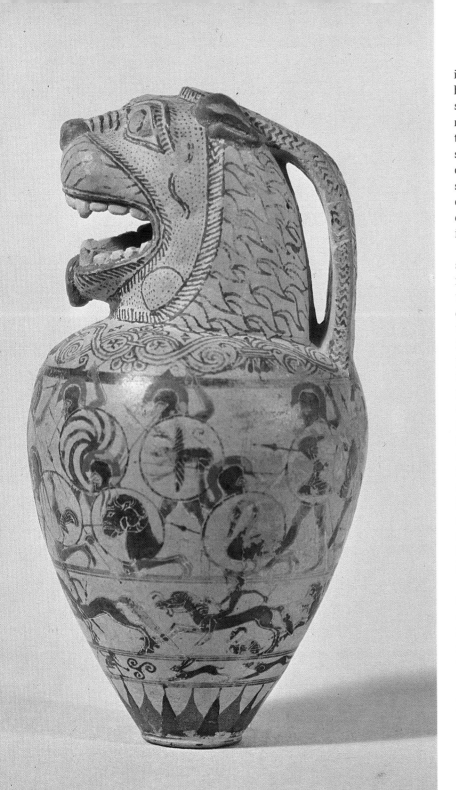

Beneath the frieze of struggling *hoplites* is a horse-race, and in the lowest zone is a hare-hunt with the hunter hiding behind a stylized bush. The lion's-head spout is rather impractical for a scent-bottle and the piece was no doubt intended as a special vase for dedication in a sanctuary or as an offering for the dead. The idea of such a head or protome is ultimately of oriental origin; it appears on a number of other early seventh-century vases, which imitate metal forms.

Attached near the rim of a miniature 23 standed cauldron, or *dinos*, we see two fully modelled ram's heads. Animal protomes were frequently attached to bronze *dinoi* in the Near East and the idea was taken up by the Greeks, who not only imitated the idea in pottery but actually produced their own bronze *dinoi*, which they frequently decorated with griffin 24 protomes. The painting on the pottery *dinos* is typical of the island of Rhodes and other Greek centres along the coast of Asia Minor in the seventh century – the style is often called the 'Wild Goat Style' after its favourite animal. All work is done in silhouette and outline; no use is made of incision. At its best, as here, this pottery is cheerfully, if naively, attractive. Subsidiary ornaments show much contact with the Near East: the palmette bushes, the rope-like guilloche and the rays on the foot.

The persistence of the silhouette-and-outline technique, despite Corinthian advances in black-figure, is to be observed in many parts of the Greek world. A large jug found on Aegina and made somewhere in 25 the Cyclades in the second quarter of the seventh century demonstrates this well. Again we have animals rendered in outline with interior markings done with paint rather than a point. The motifs are strongly oriental – the guilloche and rays again,

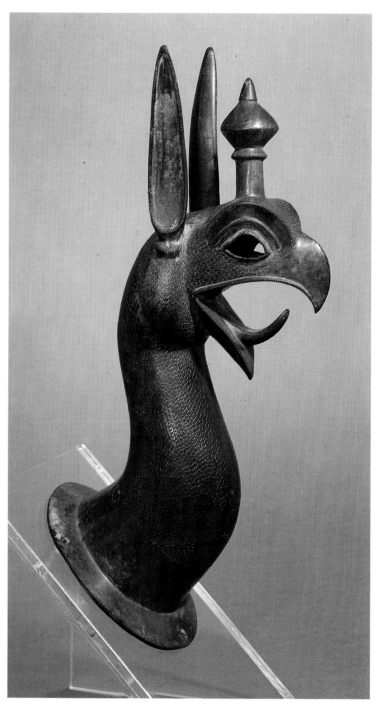

23 *Above* Early Wild Goat Style standed *dinos* showing two goats flanking a stylized 'tree of life'. Probably made on Rhodes about 670 – 650 BC. Ht 15.2cm. GR 1860.2 – 1.16.
24 *Left* Bronze griffin protome from a *dinos*, made in a Greek city on the coast of Asia Minor about 650 BC. Ht 23.4cm. GR 1870.3 – 15.16.
25 *Right* Jug with a griffin protome as a spout, showing a lion pulling down a stag, and a horse. Made on one of the Cyclades about 675 – 650 BC. Ht 41.5cm. GR 1873.8 – 20.385.

and here even the idea of a lion pulling down a stag – so too, the neck and spout of the vessel, shaped in the form of a griffin protome just like those on bronze *dinoi*. 24

This same reluctance to accept Corinthian ideas is to be found at Athens. Here the Geometric tradition was particularly slow to break up, no doubt because it had proved so successful, and inroads into the black silhouette were for a long time rather half-hearted. A fine lid in the British 26 Museum belongs late in the first quarter of the seventh century (Early Protoattic): horses graze, only their eyes and manes executed in a sort of outline, while there is a foal among them in pure Geometric silhouette. The subsidiary ornament has become much more simplified than on the

pitcher with funerary scenes, and occasional vegetable ornaments sprout from the ground.

By the middle of the seventh century (Middle Protoattic) there are some changes: we find some tentative incision for toes, beards and the like, and also some added white. For example, a large *krater*, sadly lacking its foot, is decorated with two tooth-laden lions which have outline faces but silhouette bodies. There is no incision; instead, thin white lines have been applied to mark the wavy edges of the manes and on the paws to mark the claws, while alternate teeth have been filled with white. The overall effect is very different from contemporary Corinthian work, even when it is not miniaturistic. All is angular and oversized; Corinthian artists display much more sensitivity to the structure of the animals they draw, making their contours sweep and swell with a wonderful calligraphic rhythm.

Athenian vases of the early seventh century BC are rarely found outside Athens and its surrounding countryside. By contrast, Corinthian products reached as far afield as Syria, Asia Minor and Italy. In the last quarter of the century they are also found in the first Greek trading centre in Egypt, that at Naukratis on the Nile Delta. Corinthian artists at this period were still covering their vases with friezes of animals, but their sense of form was beginning to fade and even the contrast between beasts and filling ornaments is lost as the latter decline into large shapeless blobs. An Early Corinthian (as the style is now called) *amphora* demonstrates this all too well: frieze after frieze of square, stubby creatures crowded with frosty snowflakes cover the swelling body. This same manner was to continue until nearly the middle of the following century, ever declining, even

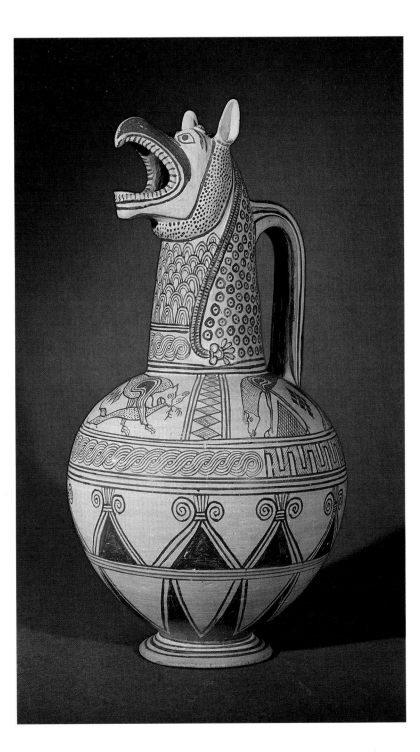

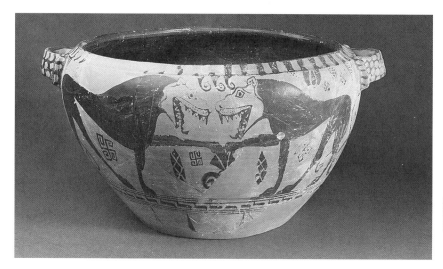

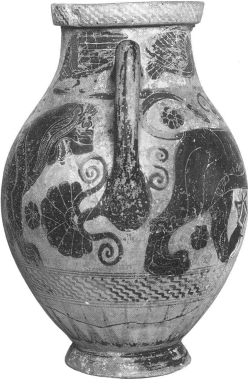

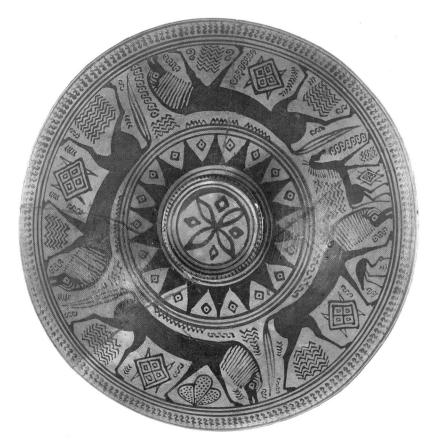

though other avenues were occasionally tried, as we shall see later.

At Athens the last quarter of the century saw the final adoption of the full black-figure technique from Corinth. A Late Protoattic *amphora*, seen here from the 29 side, shows the result. The large lions of the earlier *krater* have filled out further and developed powerful muscles, delineated now with bold incisions. Red has been added too, highlighting the mane, ear, eye, and muzzle of the lion on the left. Above, pairs of birds peck hungrily at the ground. With these monumental beasts and a full mastery of the craft of potting and painting, the Athenians were all set to move in on the markets developed by Corinth in the seventh century.

26 *Far left, below* Early Protoattic lid, decorated with horses and a foal, made in Athens about 675 BC. Diam. 25.8cm. GR 1977.12 – 11.9.

27 *Far left, above* Middle Protoattic *krater* (foot missing) showing two lions. Made at Athens about 650 BC. Preserved Ht 25cm. GR 1842.7 – 28.827.

28 *Right* Early Corinthian *amphora* with friezes of animals, made in Corinth about 620 – 600 BC. Ht 35cm. GR 1914.10 – 30.1.

29 *Left* Late Protoattic *amphora* with two lions, made in Athens about 620 BC. Ht 49.7cm. GR 1874.4 – 10.1.

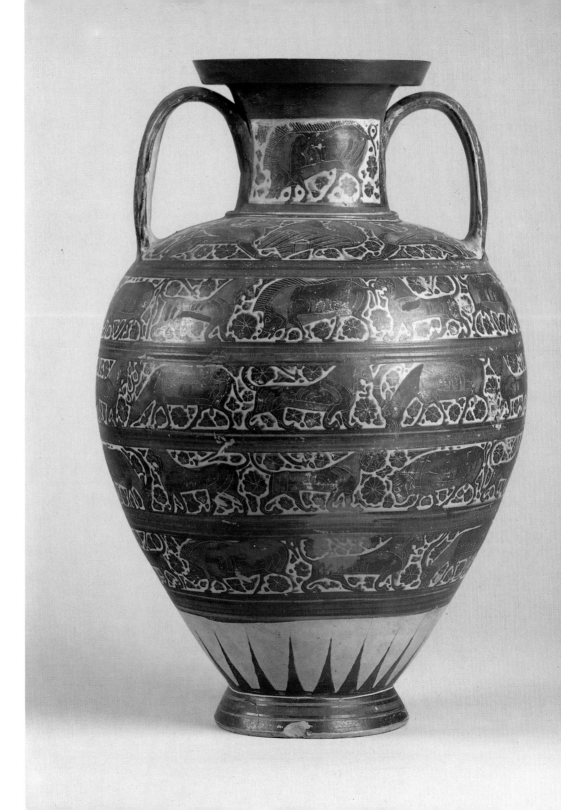

4

Athens in the Sixth Century BC

To the beginning of the sixth century belongs our first vase-painter's signature (potters' signatures go back to the beginning of the seventh). It occurs on a large cauldron, or *dinos*, made in Athens around 580 BC and preserved complete with its stand: in the upper zone, next to one of the columns of a house, is '*Sophilos megraphsen*' ('Sophilos painted me'). It is, however, quite possible in the world of Greek vases to recognize pieces by the same artist even where there is no signature, just as scholars of Renaissance painting have been able to attribute unsigned works to various artists. Following in the wake of a few German scholars, Sir John Beazley made this approach his own and succeeded in isolating both major and minor personalities, thus enabling a far deeper understanding of the development of vase-painting in the sixth and fifth centuries than has yet been possible for earlier periods. Anonymous artists are referred to in a variety of ways. Sometimes, for example, the name of the potter is used when he has signed instead of the painter, thus the Amasis Painter; sometimes the artist is given the name of the place where a particular piece was found, hence the Altamura Painter, after Altamura in Italy, or where it now is, as with the Berlin Painter; and sometimes an interesting subject provides a suitable sobriquet.

The *dinos* signed by Sophilos and its separate stand are covered with friezes of animals, both real and fantastic. The idea is taken over from Corinthian vases, although the arrangement of the animals is now more complex and more fully related to the shape of the vase. The top frieze of the *dinos*, however, is decorated not with animals but with a procession of human figures. All the participants are named and so the theme is quite clear — the gods have

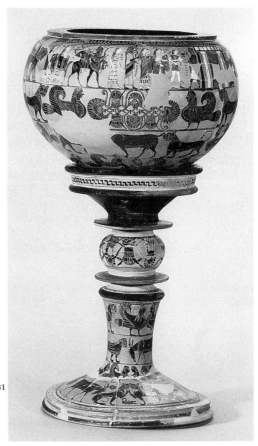

30 *Dinos* with stand painted by Sophilos, decorated with a frieze of gods and goddesses and friezes of animals and mythical creatures. Made in Athens about 580 BC. Ht 71cm. GR 1971.11 – 1.1.

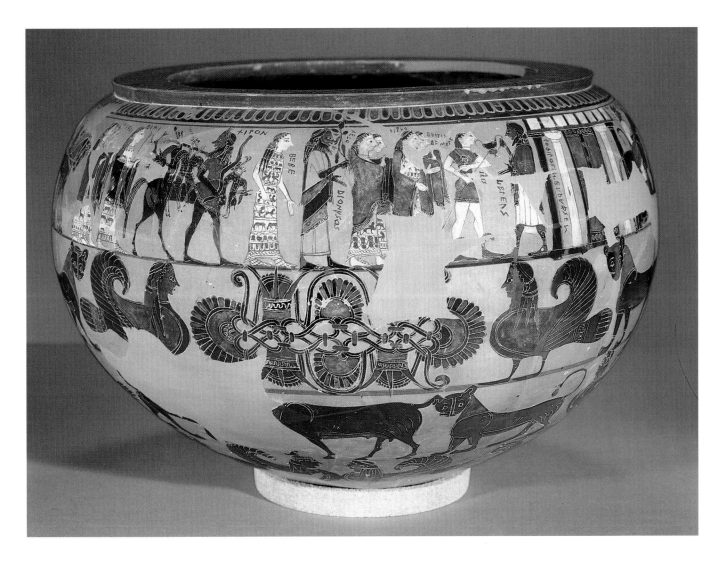

31 Detail of the Sophilos
dinos: Peleus welcomes the
gods to his marriage feast.
Made in Athens about 580 BC.
Ht of figures 8cm.
GR 1971.11 – 1.1.

come to celebrate the marriage of mortal
Peleus and immortal Thetis. Peleus stands
on the right, in front of his house with its
red door, white pillars and black *antae*
(projecting wall-ends); he is waiting for the
gods as they arrive, holding out a *kantharos*
(high-handled cup) of wine as a sign of
welcome. Iris, the messenger goddess,
heads the parade and behind her come
four goddesses, all connected with mar-

riage in one way or another; they are
perhaps looking beyond Peleus to the bride,
Thetis, hidden behind the closed doors of
Peleus'palace. Beyond these comes Diony-
sos, the god of wine, one hand grasping a
vine branch laden with grapes. He seems to
talk across the goddesses to Peleus, and it
is perhaps to him that the hero is speaking
his words of welcome. Dionysos is, in fact,
placed over the centre of the elaborate

floral in the frieze below, and so stands right in the middle of the front of a vase that was made for the mixing and serving of wine at a feast.

Behind Dionysos comes a stream of other divine guests. There are Hebe, the goddess of youth, in an elaborately woven *peplos*; Cheiron, the wise centaur, part man, part horse, with his catch over his shoulder, a welcome gift for the coming feast; and sundry other goddesses. Around the side of the vase the procession changes and the rest of the gods are paired off in chariots pulled by splendid steeds — there ride Zeus and Hera, Poseidon and Amphitrite, Hermes and Apollo, Athena and Artemis. The procession ends with a slow-moving group of gods, including fish-bodied Okeanos and crippled Hephaistos on his mule.

Sophilos' teacher was the so-called Gorgon Painter, an artist who in his early works retained something of the massiveness seen on the amphora at the end of the previous chapter. Sophilos himself, however, developed a cheerfully naive style which was continued by a group of artists who, although they also produced *dinoi*, specialized in a particular type of ovoid neck-*amphora*. Almost all of these *amphorae* have been found in Italy, especially in the cemeteries of the Etruscans (the Tyrrhenoi, as the Greeks called them) at Vulci and Cerveteri, hence their name Tyrrhenian *amphorae*. It is very likely that these vases formed part of a deliberate export drive by the Athenians, for they seem to have filled a gap in the repertoire of Corinthian vases, which had previously been preferred by the Etruscans. The decorative scheme of these vases follows on from Sophilos' *dinos*: figured scene above, animal friezes below. The subject of the figured scene on this example is taken from the stories sur-

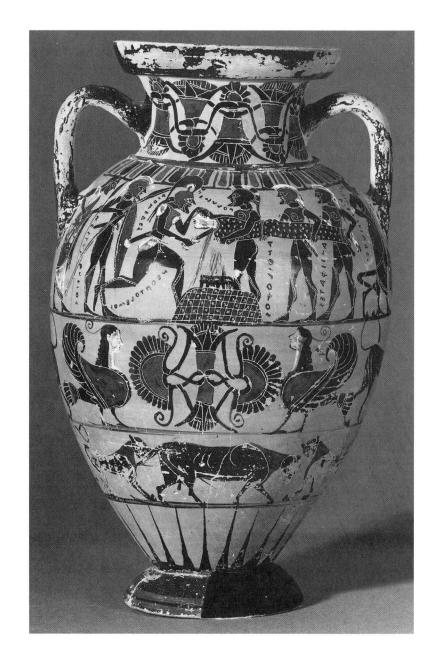

32 Tyrrhenian *amphora* attributed to the Timiades Painter, showing the sacrifice of Polyxena. Made in Athens about 570 – 560 BC. Ht 39cm. GR 1897.7 – 27.2.

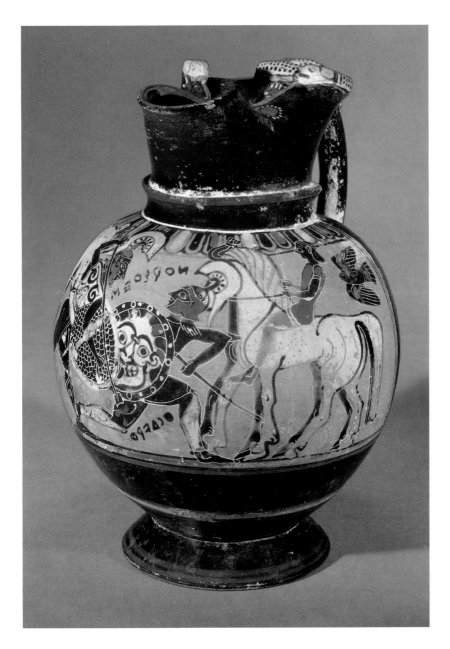

33 Late Corinthian *oinochoe* attributed to the Tydeus Painter, showing a fight. On the rim are snakes. Made in Corinth about 560 BC. Ht 23cm. *BM Cat. Vases* B 39.

rounding the war against Troy. The participants are again labelled and the subject of the scene is clear — it is the sacrifice of Polyxena at the tomb of Achilles. Three Greek warriors, Amphilochos, Antiphates and Aias Iliades (the lesser Ajax) hold the rigid figure of Polyxena over the mound of Achilles' tomb, while Neoptolemos drives his sword into her throat. Diomedes is the warrior to the left, while the old men at either extremity are Nestor Pylios (of Pylos) and Phoinix, who turns his back on the scene, perhaps in sorrow and shame.

The Corinthians, in their turn, sought to compete with Athens and in the 560s even began to coat their vessels with an orangey-red slip in imitation of the richer colour of Athenian clay. A fine jug (*oinochoe*) shows 33 a duel flanked by the warriors' squires who patiently hold their masters' horses as they sit astride their own steeds. The painter has tried to name the heroes, but the letters do not make sense, enthusiasm perhaps outstripping knowledge. Another technical feature might be noted: the white is laid directly on the clay surface and outlined. This technique is typical of Corinthian work, but rare at Athens; indeed, Sophilos was one of the few Athenian artists to employ it. His successors, such as the painter of the sacrifice of Polyxena, who is known as the Timiades Painter, placed the white on top of an initial layer of black slip.

The *oinochoe* is the work of the Tydeus Painter, one of the last of the recognizable Corinthian artists. Thereafter, Corinthian vase-painting declined into the mundane or trivial. At Athens, however, the advent of the tyrant Peisistratos brought many foreign contacts and considerable prosperity. Athenian pottery now gained domination over all the markets Corinth had previously won. It travelled west, to be buried in

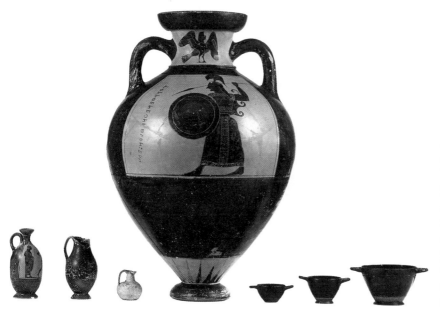

flaked off, as has the white dolphin which once decorated her shield. This example is probably one of the earliest Panathenaic prize-*amphorae* to survive and may well date to the festival of 562 or 558 BC.

Thomas Burgon discovered this Panathenaic *amphora* on 16 May 1813 in a tomb near the northern gate of ancient Athens (the Acharnian Gate). Inside the *amphora* he found, besides cremated bones, the six small vases shown here with it. One is a rather ordinary black-figured *lekythos* (oil jar), but the rest are even more modest — a plain hand-made jug and four all-black vases. The unslipped hand-made piece represents the continuation of a very old tradition. In the sixth century such small jugs are frequent offerings in tombs and sanctuaries: perhaps they were especially made for such purposes. The all-black vases, or black-glazed vases as they are usually called, belong much closer to the mainstream development of painted vessels, for they were no doubt the cheaper products of the same workshops. As potting and painting improved during the sixth century these simple black-glazed vases became very fine indeed, often combining elegant potting with a mastery of the glossy black finish.

The middle of the sixth century BC produced a number of excellent black-figure artists in Athens. One of these is known as the Amasis Painter, so called after the potter with whom he regularly collaborated. He produced a series of fine, large *amphorae*, but also some small vases, like the round-mouthed jug (*olpe*) illus- 35 trated here, which is, in fact, signed by Amasis as potter ('*Amasis mepoiesen*' — 'Amasis potted me'). The scene shows the decapitation of the Gorgon, Medusa. Perseus stands on the left turning his head away lest he be turned to stone, as he

34 *Above* Panathenaic prize-*amphora* and other vessels found in the Burgon Tomb in Athens. Made in Athens about 560 BC. Ht of *amphora* 61.5cm. *BM Cat. Vases* B 130 and B 586, with GR 1842.7 – 28.836 – 840.

35 *Right Olpe* potted by Amasis and attributed to the Amasis Painter: Perseus kills the Gorgon Medusa. Made in Athens about 550 BC. Ht 26cm. *BM Cat. Vases* B 471.

Etruscan tombs in Italy, on to France and even as far as Spain; it was exported east, deep into Anatolia and up into the Black Sea, and south to Egypt and Africa. It was prized everywhere and by everybody.

Peisistratos also seems to have done much work in the realm of religious reform. One of his achievements was to enlarge the festival of Athena, making a Greater Panathenaic Festival with games including athletics every fourth year and a Lesser Festival each intervening year. It also seems likely that he was responsible for the institution of special *amphorae* to hold the oil won by the victors. These bore on one side a representation of the event in which the winner was victorious, on the other a representation of Athena herself. On the 34 example seen here is written on the left of Athena 'I am one of the prizes from Athens'. Athena's face, arms and feet were originally painted in white over the black, but the added colour has unfortunately

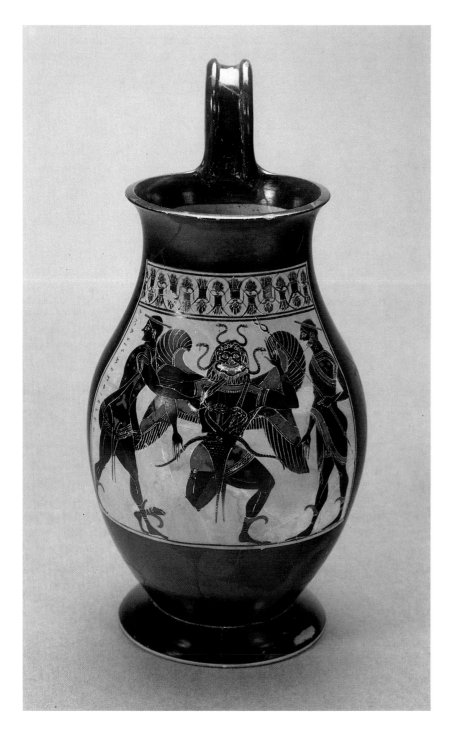

thrusts his sword deep into the monster's neck. On the far right stands Hermes, man's guide in life and death. The painting of this piece has a real delicacy and precision, very different from the rough immediacy of the followers of Sophilos. Indeed, the painter belongs closer to a tradition that depends on the work of Kleitias, whose masterpiece, the so-called François vase in Florence, is covered in a wealth of elegant miniature-painting. The Amasis Painter, however, is something more than a miniaturist: his style has strength as well as delicacy, breadth as well as precision. On this *olpe* the black-figure technique is fast reaching its acme: brush-work and incision are superbly controlled, while the beautifully balanced composition is typical of the painter's sense of form and structure.

We do not know the name of this painter for certain, but it is quite possible that potter and painter were the same man. The name Amasis is a hellenized form of the Egyptian name Ahmosis, which might at first suggest that Amasis was at least partly Egyptian; but there seems to have been a fashion among rich Athenians of the earlier sixth century for naming their sons after famous foreigners. Furthermore, we know that Amasis' son was called Kleophrades, a pure Greek name. This Kleophrades was also a potter, active in the last years of the sixth century and the first of the fifth. Such families of potters and painters passing their craft from father to son, were probably the norm, and there is some evidence for a number of others.

Another great painter of the middle of the sixth century was, however, most probably of foreign origin. This is Lydos, whose signature takes the form '*ho Lydos egraphsen*' ('the Lydian painted'). Such a signature gives us a rare and important insight into

the status of some of the painters at Athens at this and, perhaps, other periods. The welcome offered by Athens to foreign craftsmen from the beginning of the sixth century was clearly attractive, for we hear of other potters and painters whose names suggest foreign birth: in addition to Lydos the Lydian there was Skythes from Scythia, Mus from Mysia, Sikellos from Sicily, Thrax from Thrace and Syriskos from Syria. Some of these craftsmen may have been what the Athenians called *metoikoi* (foreign residents), but others were slaves, as the signature of another Lydian late in the sixth century demonstrates, for he signed as '*Lydos ho doulos*' ('Lydos the slave').

The earlier, and greater, Lydos decorated a variety of shapes including *dinoi* and neck-*amphorae*, which, like his cheerfully bold style, link him back through the Tyrrhenian *amphorae* to Sophilos. One vase, however, looks like an *amphora* but is really much more. The potter, possibly Amasis, has made a vase within a vase — the normal inner chamber accessible through the top, the invisible outer chamber through a round spout in the side and a hole in the base. This sort of vessel (a *psykter-amphora*) was used for cooling wine: the cold water was poured into the outer chamber, the wine into the inner. A number of similar vessels were also produced by a group of Greek artists who seem to have emigrated to one of the colonies in southern Italy around this time and created some very fine vases in the second half of the sixth century (so-called Chalcidian vases).

The scene on the front of this vase emphasizes its function: Dionysos stands to the right of the spout, drinking horn in hand. A maenad and three satyrs accompany the god of wine, while under the spout a young, hairless satyr plays with a

36

37

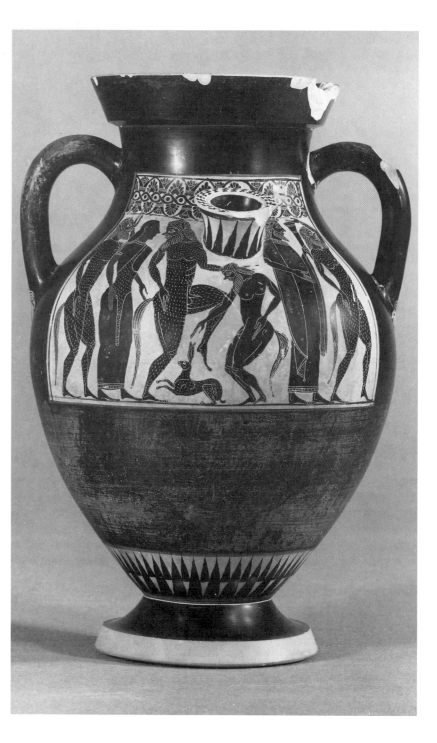

37 Section through the *psykter-amphora* attributed to Lydos. Drawing by Susan Bird, from an X-Ray photograph.

36 *Psykter-amphora* attributed to the painter Lydos, showing Dionysos with satyrs and maenads. Made in Athens about 550 BC. Ht 40.2cm. *BM Cat. Vases* B 148.

hare. Dionysos' cloak shows a new feature — a zigzag fold. The gradual development of an understanding of drapery folds goes hand in hand with an increasing perception of the way the human body is constructed; both help us to chart the course of Greek vase-painting.

The third great artist to appear around the middle of the sixth century was perhaps the finest of all painters to use the black-figure technique. His name, Exekias, is known from several signatures, both as potter and as painter. His painting combines the monumentality of Lydos with the delicacy of the Kleitian tradition. He was a master of speaking contour and form, as well as of incision. His potting is crisp and clear; indeed, both his vases and his figures seem filled with life and air.

The British Museum has a splendid *front* neck-*amphora* signed by Exekias as potter. *cover* The painting is his, too. In a basically square but curving field he has created a bold triangle. Achilles, the hero of Troy, thrusts down with his spear into the throat of Penthesilea, queen of the Amazons. She has sunk to the ground as blood gushes from her throat. Their eyes seem locked together in this last moment of violence, but also perhaps the first moment of something more. Exekias achieves this sort of psychologically potent moment on a number of his other vases, and one need not perhaps dismiss as the creation of a later and more melodramatic age the story that Achilles fell in love with Penthesilea at the very instant in which he killed her.

In addition to the names of the two protagonists and the signature of Exekias, on the right of the group are the words 'Onetorides kalos' ('Onetorides is beautiful'). This idea of praising someone's beauty, both male and female (but male much more frequently), begins around the middle of the sixth century and lasts through most of the fifth. The intention seems to be to praise the favourite youth (or courtesan) of the moment. These golden boys of the Athenian upper class, however, came and went and one can trace the ever-changing parade from the vases. For at one moment a youth like Onetorides will be praised by a number of painters, but after a while his name will be replaced by another's.

We wonder at this vase's remarkable figured scene, at the brilliance of Exekias' incised markings on armour, animal skin and cloth, at the delicate restraint of the added colours, at the calligraphy of the inscriptions and at the unerring precision of the subsidiary decoration. But Exekias

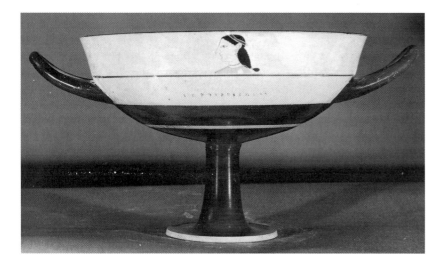

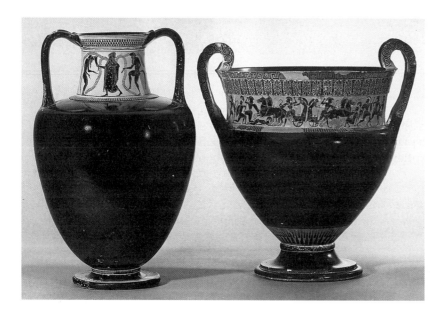

38 Cup attributed to the painter Sakonides, decorated with the head of a woman. Made in Athens about 540 – 530 BC. Ht 15.5cm. *BM Cat. Vases* B 401.

39a Neck-*amphora* potted by Andokides and attributed to the painter Psiax (left). The scene on the neck shows Dionysos and satyrs. Made in Athens about 530 – 520 BC. Ht 39.5cm. GR 1980.10 – 29.1. (**b**) Volute-*krater* potted by Nikosthenes (right), showing scenes from a fight. Made in Athens about 530 – 520 BC. Ht 37.5cm. *BM Cat. Vases* B 364.

signed as potter and our last word should perhaps be about the vase itself. The body is so finely potted and the contours so tight that it almost seems as if touching the vase would either cause it to burst like a bubble or gently lift off like a balloon. The added elements, foot, handles and neck, all have the same clarity and perfection, while the careful preparation of the surface (Exekias must have given it a very fine wash of ochre to enhance its colour) and of the black slip have given him the perfect basis for what is truly a masterpiece of potting as well as painting.

With excellence came experiment. Exekias tried the effect on some of his vases of a pinky-red slip, further enhancing the surface. This technique, called coral red, was only infrequently used, perhaps because it was hard to control and had a tendency to flake off. Other artists, like the Amasis Painter, employed more outline work than usual, often replacing the added white customary for female flesh with simple outlining. On the rim of a cup made 38 soon after the middle of the century, for example, is an outline head of a woman. The painter of this piece was Sakonides, one of the miniaturists who specialized in decorating these elegantly fashioned cups, another was the Phrynos Painter, who gave 4 us the portrait of Athena, the patroness of potters.

Such experiments were continued by two other potters, Nikosthenes and Andokides, whose competition in vases decorated in the regular black-figure technique is neatly shown by two unusual vases in 39 the British Museum. One is a volute-handled *krater*, the other a neck-*amphora*. Both are exceptional in shape, probably being derived directly from metal prototypes, both have their figured decoration confined to the neck and both bear the

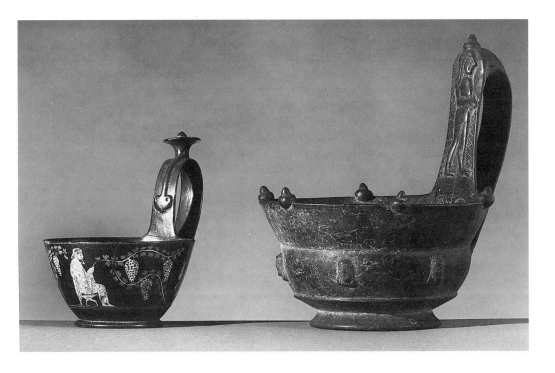

40a Six-technique *kyathos* (left), showing Dionysos. Made in Athens about 530 – 520 BC. Ht 13.8cm. *BM Cat. Vases* B 693. (**b**) Etruscan *kyathos* (right), made in Etruria in the sixth century BC. Ht. 19.8cm. *BM Cat. Vases* H 222.

signature of their potter on the top of the rim.

39b Nikosthenes, who signed the volute-handled *krater*, was a particularly inventive potter with an exceptional eye for what would sell in the profitable market of Etruria. One of the shapes he developed for 40 this outlet was the wine-dipper (*kyathos*), based on a native Etruscan form that was completely black. An elaborate Etruscan example with moulded additions is shown next to a Nikosthenic version. Perhaps to make this connection even more compelling, a new technique of painting has been used here, one which left most of the vase black. This new technique, called the Six technique after Jan Six who first studied it, is really an extension of that used for the white faces of women to include the whole decoration. The complete figure is now rendered in thickly applied whitish clay

slip, inner details being marked with incision or added red. On this example the figured scene is kept to a minimum – Dionysos, seated on a stool, a heavily laden vine branch in one hand.

The Six technique has a certain freshness, but it does not seem really to have caught on and is soon confined to just a few shapes with ritual or funerary functions, such as *phialai* (bowls) and *lekythoi*. Nikosthenes' other new technique, however, was to prove much more lasting and much more important for the future of vase-painting. This is the idea of painting on a white slip which was applied to the whole vase, an idea probably borrowed from the 'East Greek' cities on the coast of Asia Minor where the technique was particularly common. Nikosthenes seems, indeed, to have borrowed much from the East, including some shapes. The *phiale*, a

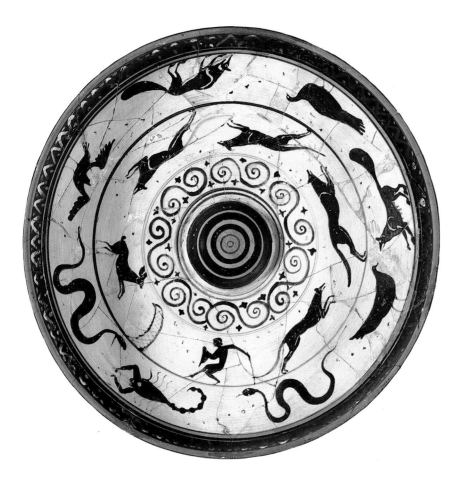

shallow bowl for pouring libations, is one of these, and the British Museum has a unique example with a white slip on the interior. This piece, like the *kyathos* discussed above, is not signed by Nikosthenes as potter, but the shape and manner of decoration suggest that it is from his workshop. The drawing, which is done in the black-figure technique, slightly modified to make it look a little like the products of the 'East Greek' cities, depicts in an inner frieze a hare-hunt and beyond, in an outer zone, a menagerie of foxes, partridge-like birds, snakes and a scorpion fancifully playing the pipes.

The other new technique invented around 530 BC is known as the 'red-figure' technique. It is the reverse of the black-figure scheme with its black figures on a red ground, for it has red figures against a black ground. It is important to realise, however, that these red figures are not achieved by painting with a red colour, but rather by painting the background and leaving the figures reserved in the natural orangey-red colour. We do not know who invented this technique, although Nikosthenes' interest in new ideas, the fact that some of the earliest examples of the new technique are to be found on unusual shapes, and the similarity in effect between the Six technique and the red-figure technique all make one wonder if he was its inventor. A small fragment of a cup found at Naukratis in Egypt illustrates this possibility showing how the new technique looked in its early stages. The fragment is, in fact, from a cup of the same shape as that decorated by Sakonides, only the figured scene is, exceptionally, on the inside of the lip. The scene is taken from a feast or *symposium* – a figure reclines, *phiale* in hand, a cloak round his waist and legs and a cushion under his arm. The

41 *Above* White-ground *phiale* decorated with a hare-hunt and animals. Made in Athens about 520 BC. Diam. 21.7cm. *BM Cat. Vases* B 678.

42 *Below* Fragment from the lip of a cup showing a youth reclining at a banquet, made in Athens about 530 – 520 BC. Ht 7.3cm. *BM Cat. Vases* E 134,2.

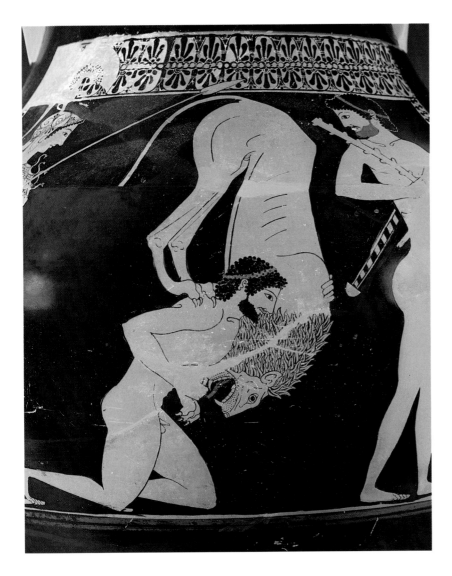

43 Detail from an *amphora* attributed to the Andokides Painter, showing Herakles wrestling with the Nemean lion. Made in Athens about 520 BC. Ht of figured scene 18cm. *BM Cat. Vases* B 193.

proudly signed. He was, however, more discriminating in the choice of his painters. The *amphora* was decorated by Psiax, a *inside front cover* particularly adaptable painter who has left us works like this in a superb miniature black-figured style, pieces employing coral red, white ground, Six technique and red-figure. If any painter had a hand in the development of the red-figure technique, Psiax would be a good candidate.

Andokides also used an anonymous artist whom we call the Andokides Painter. In his hands the red-figure technique achieved stability and began to show its real potential: incised lines in a black silhouette, however carefully executed, are inevitably less fluid than those painted by a brush, and all interior markings on figures could now be done in just this way. In addition, the black background seems to make the more naturally coloured figures stand out in three dimensions.

A number of vases of this period are sometimes called 'bilinguals', for on one side they are decorated in the old black-figure technique, on the other in the new red-figure scheme. Both Andokides and Nikosthenes produced such pieces. A detail from the red-figured side of a bilingual 43 *amphora* decorated by the Andokides Painter (his partner, the Lysippides Painter, was responsible for the black-figured side) shows Herakles wrestling with the lion that terrorized the area around Nemea near Corinth. The red-figure technique has been improved since the cup fragment, for the 42 painter here marks the contours of his figures with a bold, three-dimensional line nowadays called a 'relief line'. This line seems to have been achieved by using a much thicker mixture of slip. In addition, the painter also began to experiment with the effect of thinning his slip to produce a light brown colour. This thinned slip was

drawing is very simple and the technique clearly unpractised.

The name, however, that most modern scholars associate with the inception of the red-figure technique is Nikosthenes' rival, Andokides. Andokides was perhaps a less inventive potter than Nikosthenes — his only original shape is the special *amphora* 39a with handles reaching to the rim, which he

eventually used to mark the numerous minor modulations of the body, such lines being called 'dilute glaze lines'. There are also, on this example, high-relief blobs to imitate curls on Herakles' head. Finally, added red is still used, but much more sparingly than in the black-figure technique, for fillets around the hair and, here, the lion's tongue.

Herakles was a very popular hero throughout the Greek world, but in Athens in the second half of the sixth century this popularity seems to have bordered on something of an obsession. John Boardman has, therefore, suggested that this might reflect an interest taken by the Peisistratid tyrants in Herakles as a vehicle for propaganda, much as the Athenian democracy's interest in Theseus in the fifth century appears to have been political. The idea seems very plausible, but it is, as yet, impossible to prove. The approach is, nevertheless, a fascinating one and encourages the viewer of Greek vases to set them in a historical and political context. Other vases, some of which we shall see later, also reflect social customs and religious events, so that there are many different approaches to the study of the scenes on Athenian vases.

We turn now to a painter who was employed by both Andokides and Nikos-

44 Detail from a cup attributed to the painter Euphronios: two warriors. Made in Athens about 520 – 510 BC. Ht of figures 8cm. *BM Cat. Vases* E 41.

45a *Hydria* painted by Phintias (left): youths collecting water at a fountain. Made in Athens about 510 BC. Ht 54.1cm. *BM Cat. Vases* E 159. (**b**) *Hydria* attributed to the Leagros Group (right), showing two quarrelling heroes. Made in Athens about 510 – 500 BC. Ht 50.7cm. *BM Cat. Vases* B 327.

thenes, and that is Epiktetos. Epiktetos worked in black-figure, but his best work was done in the new red-figure technique, especially on cups and plates. On a signed *title page* plate we see two revellers; one plays the pipes, the other bends to lift a large *skyphos* (deep cup) from the floor. The languid vertical of the piper as he gently rocks forward on to his toes, the supply arched back of the man with one boot-clad foot balancing the heavy *skyphos*, together with the neat letters of Epiktetos' signature as painter, all combine to produce a superb composition. Beazley's comment on Epiktetos that 'you cannot draw better, you can only draw differently' is amply borne out by the flowing contours of these spare figures, their clear features and the

smoothly rippled drapery over the man's back.

Alongside Epiktetos, who was completely at home with the red-figure technique, there emerged a group of experimenters, 'Pioneers' as they are sometimes called. One of these was Euphronios. Here we see 44 a detail from an early work of his, a cup. His painting is technically excellent and superbly precise: he owes much to his teacher, Psiax. Later in his career Euphronios achieved a remarkable virtuosity, rendering every wrinkle and knuckle and, one sometimes feels, every bone and sinew within, as if his figures were flayed anatomical specimens. But besides the elegance of Epiktetos' creatures, his can seem a little wooden.

These Pioneers, so called because of their exploration of new complicated poses and views, also included Phintias. On a 45a water jar (*hydria*) signed by Phintias as painter we see youths fetching water from a lion's-head spout. The youth on the left is a fine study in strain, his elbows clamped tightly to his side as he holds his heavy *hydria*, while one of his fellows is distracted by a man behind him, causing him to twist right round, his left arm following the movement. There is much additional anatomical detail in dilute glaze, but this is really only visible on the vase itself.

The Pioneers – Euphronios, Phintias, Euthymides, and a fewer lesser figures like Smikros – were clearly a close-knit group of artists. Sometimes they wrote challenges or greetings to each other on their vases and sometimes they labelled their figures with each other's names. Euphronios called one of his symposiasts Smikros; Smikros called one of his athletes Euphronios (he also labelled himself in one of his own *symposia*); and Phintias called a young music student Euthymides. This sort of identification with the activities of the better-off young Athenian citizens might, of course, be nothing other than pure wishful fantasy, but from the last quarter of the sixth century we find a number of expensive dedications on the Athenian Acropolis that name potters and painters such as Andokides and Euphronios, and these, together with the deliberate exploration of the boundaries of painting, may suggest that the Pioneers not only could but actually did mix in gifted artistic circles, which also included the youthful rich of Athens.

Next to Phintias' red-figured *hydria* is a 45b late black-figured piece produced by a member of a circle of artists, known as the Leagros Group (named after the youth praised on some of their vases and on some by the Pioneers), a group which endeavoured to compete with the Pioneers. The scenes on their vases are often violent in theme and heavy with complicated black masses. Here, two quarrelling heroes are only pulled apart with difficulty; their legs and arms restlessly criss-cross the surface. The effect is powerful and dramatic, but the painters could not compete with the flexibility of red-figure and the talent of its practitioners. Black-figured painting soon passed into the hands of minor painters of slight vases, until it eventually died out around the middle of the fifth century – the only exception being, as we shall see, the Panathenaic prize-*amphora*. Outside Athens the black-figure technique, which had been taken up in the sixth century in a number of regions, including Italy and the 'East Greek' cities, as well as mainland Greece itself (Euboea, Sparta and Boeotia), similarly came to an end around the close of the sixth century BC or soon after. Only in Boeotia did a significant but bizarre tradition continue during the fifth century.

46 *Right* Neck-*amphora* attributed to the Berlin Painter, decorated with an ageing reveller. Made in Athens about 490 BC. Ht 49.4cm. *BM Cat. Vases* E 266.

5

Athens in the Fifth Century BC

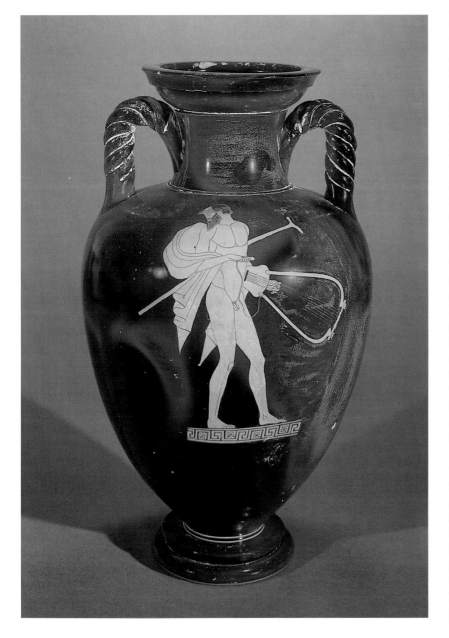

With the fifth century the quantity of painted pottery being produced at Athens seems to have risen. One of the causes of this was an increase in the degree of specialization by painters and potters. Around 500 BC there emerged some painters who concentrated on decorating pots (larger vessels), while others specialized in cups and related small vessels. One of the finest painters of pots in the early fifth century is known as the Berlin Painter, so named by Beazley after a vase in that city. He was a pupil of the Pioneers, in particular of Phintias and Euthymides. A splendid neck-*amphora* with twisted handles gives 46 us a good idea of his quality and style. In a sea of brilliantly black glaze the painter has isolated, as if under a spotlight, the figure of an ageing reveller. He walks along, *barbiton* (long lyre) pressed against one hip, the fingers of his left hand at its strings, those of his right gripping a plectrum. A stick is slipped nonchalantly under his arm and a plain cloak surrounds his shoulders. His head and body turn, his attention seeming to be caught by the sudden billowing of his cloak. His lithe body is strangely both tense and languid: his muscles and sinews are taut, but his down-turned head and slightly flexed knees impart a sense of languorous grace. This effect is to be found in a number of the Berlin Painter's other figures.

Beazley's method of attributing vases to particular hands is based on, among other things, a close observation of every line that goes to make up the painting, for every line is personal to its painter, part of his own individual 'handwriting'. In the case of the Berlin Painter there are a number of easily recognizable features to his style, such as the little triangle at the junction of the lower contours of the pectorals and the pincer-like form of the ankle-bone. Many

other features and details combine to enable us to make an attribution to the Berlin Painter, including subsidiary ornament and overall conception.

The Berlin Painter's special talent lay in his ability to build small, elegant details into a graceful, living whole and then set his figure or group in perfect harmony with the vessel he was decorating. Thus, in this case, the curve of the shoulder of the vessel seems to complement the bunching of the reveller's drapery, while the turn of his head echoes the change in direction of the surface.

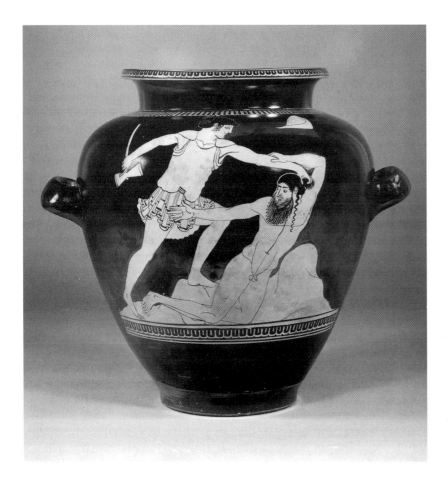

47 *Stamos* attributed to the Kleophrades Painter, showing Theseus and Prokrustes. Made in Athens about 490 – 480 BC. Ht 31.9cm. *BM Cat. Vases* E 441.

The other great pot-painter of this period is known as the Kleophrades Painter. His name derives from the fact that early in his career he decorated a pair of very large cups for the potter Kleophrades, the son of Amasis. The Kleophrades Painter's figures contrast strongly with those of the Berlin Painter: they are massive, heavy-set and powerful, as can be seen on a storage jar (*stamnos*) showing Theseus killing the robber Prokrustes, one of the bandits he met and disposed of on his journey to Athens. Details of style also differ from those of the Berlin Painter. There are, for example, no triangle at the junction of the pectorals and no pincer-like ankle-bones; instead, we have a solid line continuing from the pectorals down the median line as far as the navel and simple L-shaped ankle-bones. Other characteristic features are the arc-like depression between Theseus' clavicles and his incised hair contour. This latter feature, in fact, belongs to the formative years of the red-figure technique, before the idea of leaving a reserved contour had been developed. The Kleophrades Painter's liking for it may reflect not a reactionary tendency but a desire to reduce the artificial boundary between hair and air to a minimum.

The Kleophrades Painter's teacher was the Pioneer, Euthymides, and one of the lessons that he, like the Berlin Painter, learnt was the device of the three-quarter foot – used here on Prokrustes. The robber's three-quarter face, however, is a new development that we begin to see around 490 BC. Both devices are intended to add depth to a two-dimensional representation, as is the Kleophrades Painter's own idiosyncratic extension of the median line down from the pectorals to the navel. The double curve of this line turns it into a modelling line, thereby suggesting the full-

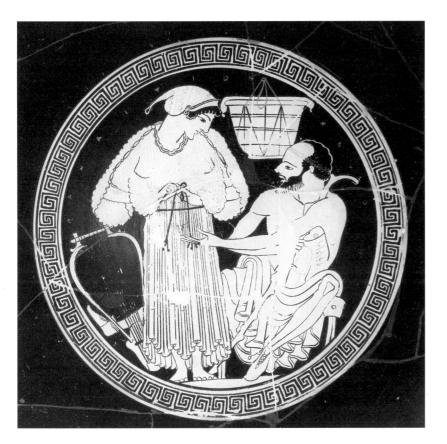

48 Interior of a cup attributed to the painter Onesimos: a reveller and a courtesan. Made in Athens about 500 – 490 BC. Diam. of tondo 18.6cm. *BM Cat. Vases* E 44.

earliest works depend heavily on Euphronios' style, but there is from the beginning a fresher, more vital spirit at work. From the interior of one of his early cups comes a simple but intimate human scene: an ageing reveller is seated on a low stool, one hand gripping his knotted stick, the food-basket above his head and the lyre by one foot setting the time and the place – an evening's feast. Before him stands a *hetaira* (courtesan) who wears a fancy hairnet and a fine linen *chiton*, so fine, indeed, that it is transparent. Her hands are at the cord around her waist; she is holding up her *chiton* to the right length by keeping her wrists to her sides as she does up her girdle. He reaches out one hand towards her and his mouth opens as he perhaps tries to dissuade her from leaving so soon. The way his legs surround her suggests the possession that he longs to extend, but his furrowed brow and pleading gesture reveal the hopelessness of his case. There is, however, understanding and tenderness in the way her head bends down towards him and in her gentle self-possession.

The frontal pose of the *hetaira*, the man's frontal lower leg and completely foreshortened upper leg are all ideas that have grown out of the experiments of the Pioneers. Euphronios himself signed this cup as potter on one handle. He seems to have begun his career as painter and then turned to potting, a change of course that might reveal something of the relative importance of the two activities. In the black-figure technique we know the names of six times as many potters as painters. With the invention of the red-figure technique, however, the number of painters' signatures increases, and this may reflect an increase in the status of painters, although it is likely that potters always remained more important.

ness of chest and stomach. It is often assumed that such ideas are borrowed from free painting, whether on wall or panel. This is, of course, quite possible and indeed a number of such borrowings seem to have been made around the middle of the fifth century, as we shall see later, but it need not be true in the first quarter; one can actually observe some painters of this period experimenting with and developing such ideas and techniques for themselves.

Alongside the two great pot-painters a number of fine cup-painters also emerged from the school of the Pioneers. Perhaps the best and most influential of these was Onesimos, a pupil of Euphronios. His very

Another cup-painter to emerge from the Euphronian arm of the Pioneers was Douris. He regularly collaborated with a potter called Python, but he also occasionally turned his hand to potting as well. He was certainly a prolific painter, leaving us nearly three hundred examples of his work. It has been suggested that we have, in fact, only about three per cent of the total production of ancient Greek vases. If this estimate is correct, Douris could have painted as many as ten thousand vases in a career which seems to have lasted from about 500 BC to 470 BC — this would be about one a day, allowing for high days and holidays.

Douris, like most of his fellow cup-painters, did, however, paint a few other shapes. The British Museum has a particularly fine *psykter* signed by Douris, a mushroom-shaped wine-cooler that replaced the multiple vessels seen around the middle of the sixth century, the new shape being perhaps an invention of Nikosthenes. It was filled with wine and set to float in a *krater* of ice-cold water. Douris' decoration spreads right around the body, and the subject chosen is directly relevant to the vase's connection with wine, for we see a troop of satyrs, the companions of Dionysos, aged as usual by their debauchery but still capable of cavorting wildly in a boisterous ballet. They dance, do handstands, and one performs a prodigious feat of balancing, made even more remarkable by the imminent addition of wine into the *kantharos* so proudly and precariously poised.

Douris' drawing is very elegant and controlled. His earlier works, like the *psykter*, have some fire as well as elegance, but his later vases tend to become more academic. Two typical features of his style can be seen on the London satyrs: the

w-shaped hip line and the small arc at the junction of the lines marking the lower boundary of the pectorals. The latter feature recalls the similar marking on the Berlin Painter's works, but a closer look will reveal the difference: the Berlin Painter's seem to be part of the chest; Douris' are extra appendages. Both are personal stylizations of an observable feature of a well-developed male chest.

Alongside such red-figured vases we also find pieces decorated in outline over a white ground. The use of a white slip was, as we saw, developed around 530 BC. At first the decoration was done in the regular black-figure technique, but soon the effect of outline drawing was tried. This idea was quickly taken up, especially by artists now trained in the red-figure technique. Onesimos and Douris both tried it, but one of the most successful and best preserved examples was painted by another cup-painter of the period whom we call the Brygos Painter after the potter for whom he usually worked. This example is not, however, on a cup but on a jug. Here we see the lone figure of a women spinning wool; she uses a short distaff and a weighted spindle — a method still to be found in isolated parts of Greece even today. She is a model of serious concentration, head slightly bent as she watches the thread. But who is she? Is she a dedicated housewife, or perhaps one of the Fates, spinning the thread that carried man's destiny? We cannot know; indeed, the very ambiguity of a scene is something on which Greek artists often played.

The unusual technique and exceptional quality of this vase suggest that it was designed as a special piece to be given as a gift or dedication. It would indeed have made a very suitable gift for a woman on her wedding — an image to emulate — or

49

back cover

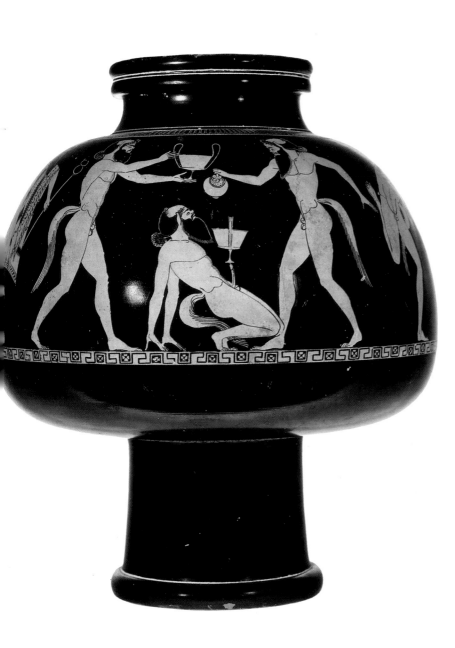

49 *Psykter* painted by Douris with cavorting satyrs. Made in Athens about 500 – 490 BC. Ht 28.7cm. *BM Cat. Vases* E 768.

for a woman on her death — a memorial to what she had been. It is said to come from Locri in southern Italy and its perfect preservation suggests that it may well have come from the tomb of a Greek settler there. Greeks had, in fact, made much of the coastal districts of southern Italy and eastern Sicily their own, so much so that the whole area later came to be called *Magna Graecia* ('Great Greece').

From the northernmost part of the Greek sphere of influence in Italy, from near Capua in Campania, comes a remarkably rich grave group. The grave had been robbed in antiquity, its metal vessels and jewellery stolen, but seven superb vases were left and they are now reunited in the British Museum for the first time since their discovery. One of the finest of the vases, the cup, is signed by Brygos as potter on the edge of the foot, and so Beazley dubbed the tomb the 'Brygos Tomb'. It was, however, the large *skyphos* signed by the potter Hieron that most caught the attention of scholars in the early 1870s when the tomb was discovered, particularly because of its representation of Eleusinian deities. Different times will always have different tastes and interests.

Brygos' cup was decorated by the Brygos Painter, like the white-ground jug with the spinster. The tondo inside shows the warrior Chrysippos pouring a libation with the aid of a girl called Zeuxo before leaving for battle, a quiet, moving scene in contrast to the riot outside, where satyrs threaten the gods themselves. There, the queen of the gods is protected by Hermes and Herakles from a slightly hesitant band of satyrs on one side, but on the other side Iris has no such protectors and is quickly caught by a more unbridled troop, egged on by Dionysos himself.

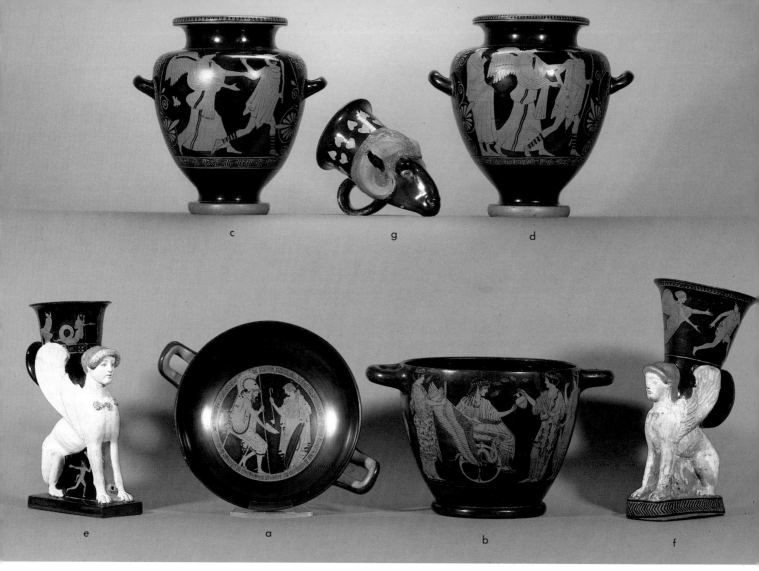

50 Pottery from the Brygos Tomb near Capua:

a cup potted by Brygos and attributed to the Brygos Painter: Chrysippos and Zeuxo. Made in Athens about 490 – 480 BC. *BM Cat. Vases* E 65;

b *skyphos* potted by Hieron and attributed to the painter Makron: Triptolemos about to take corn to mankind. Made in Athens about 490 – 480 BC. *BM Cat. Vases* E 140;

c *stamnos* attributed to the Deepdene Painter, showing Eos and Kephalos. Made in Athens about 470 – 460 BC. Karlsruhe B 1904;

d *stamnos* attributed to the Deepdene Painter, showing Eos and Kephalos. Made in Athens about 470 – 460 BC. New York 1918. 74.1 (Rogers Fund);

e sphinx *rhyton* attributed to the potter Sotades and the Sotades Painter, and showing Kekrops and his daughters (?). Made in Athens about 470 – 460 BC. *BM Cat. Vases* E 788;

f sphinx vase attributed to the Tarquinia Painter depicting Eos and Tithonos (?). made in Athens about 470 – 460 BC. Ht 33.8cm. *BM Cat. Vases* E 787. The addition of this piece is based on an explicit note in the original list of the British Museum's acquisitions from Castellani, written in Italian and preserved in the Central Archive.

g ram's head vase attributed to the potter Sotades. made in Athens about 470 – 460 BC. *BM Cat. Vases* E 800.

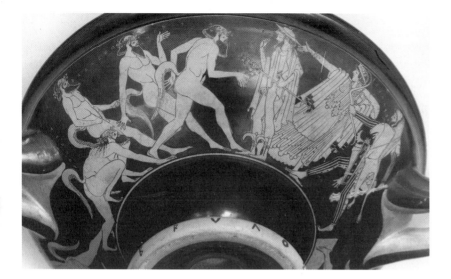

51 Cup potted by Brygos and attributed to the Brygos Painter: satyrs attack Hera. Signed on the edge of the foot. Made in Athens about 490 – 480 BC. Diam. 27.6cm. *BM Cat. Vases* E 65.

The decoration of Hieron's large *skyphos*, however, is much more sober. The painting is by Makron, another cup-painter of the first quarter of the fifth century who, like Douris and the Brygos Painter, was much influenced by Onesimos. Here we see an important religious event, Triptolemos in his magical winged and wheeled seat about to set off to bring corn to mankind. Persephone is on the right, helping in the farewell libation, while behind the chariot is Demeter, her mother. On the extreme right is the charming young figure of the nymph Eleusis, for it is at Eleusis that the event is taking place, and the torches held by Persephone and her mother are the typical paraphernalia of the Eleusinian Mysteries. Makron was particularly fond of elaborate drapery and his painting of Demeter's cloak recalls those worn by some of the goddesses on Sophilos' *dinos*, although there is a world of difference in the understanding of a garment's material and the way it hangs.

These two vases from the Brygos Tomb date around 490-480 BC, but the remaining pieces of the group date from after the Persian Wars, indeed to the decade 470-460

BC. It is likely that the two earlier pieces were prized possessions of the dead, whereas the later vases were bought especially for the burial. This latter idea is further strengthened by the fact that two of the later vases are in the form of a sphinx, a guardian of the dead, and that there is a definite concentration in the figured scenes on abduction, a theme which was often associated with untimely death.

The two *stamnoi* (storage jars), which were not bought by the British Museum at the time of their discovery, but were sold later, one going to the Badisches Landesmuseum in Karlsruhe, the other to the Metropolitan Museum of Art in New York, are by the same painter, the Deepdene Painter, and the same potter (perhaps called Oreibelos). The Deepdene Painter is a capable artist but his painting never rises above the purely decorative: scheme, movement and gestures all derive from earlier works, but the fire and passion are gone; drapery is more severe and less calligraphic. The same may be said of the painter of the rougher and less well preserved of the two sphinx vases, the Tarquinia Painter. He carried on the tradition of Onesimos and his followers and was chiefly a cup-painter, unlike the Deepdene Painter who specialized in larger vases, especially *stamnoi*.

The remaining two vases, the more elaborate sphinx-vase and the vase in the shape of a ram's head, are from the workshop of the potter Sotades. Sotades was an inventive potter who seems to have been particularly fond of vases with modelled parts. The interest shown in the fifth century for such vases is, as it was in the seventh, the result of contact with the East, in particular now with Persia. Sotades' sphinx is a true *rhyton*. Wine was poured into it, with the spout between the legs

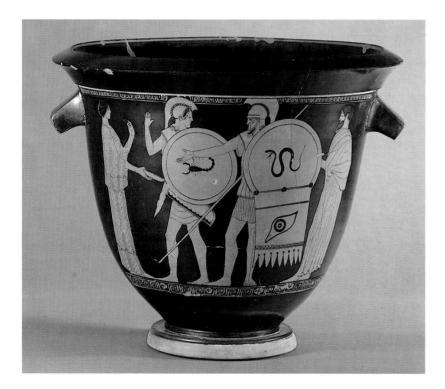

52 Bell-*krater* attributed to the Altamura Painter, showing the departure of two warriors. Made in Athens about 470 – 460 BC. Ht 40.5cm. GR 1961.7 – 10.1.

subjects to his market. This fact raises the possibility that the deceased in the case of the Capua tomb was an Athenian and not the Etruscan he is usually thought to have been, since the red-figured decoration on the rim of our sphinx vase centres around purely Athenian figures – Kekrops, a legendary king of Athens, and his children. Furthermore, the Athenian connection seems to be maintained on the Deepdene Painter's two *stamnoi*, which both show, on one side, Eos chasing Kekrops' son, Kephalos, while the reverse of the Karlsruhe *stamnos* has yet another Athenian myth, Boreas carrying off Oreithyia, daughter of Erechtheus, a second legendary king of Athens.

Besides the delicate, almost miniature works of the Sotades Painter and the duller, heavier efforts of the Deepdene Painter and others like him, there was in the second quarter of the fifth century a group of artists working on a large scale who achieved both dignity and presence. On a monumental bell-shaped *krater* by one of 52 them, known as the Altamura Painter, the departure of two warriors is depicted. It is impossible to tell whether the scene is mythical or contemporary, but whatever the painter had in mind, the Athenian viewers of the scene must have thought of the Persian invasions and their own heroically stubborn defence of their city. Broad, plain surfaces and deliberate gestures have secured a real grandeur and a sense of determination.

It is in the workshop of the Altamura Painter and his follower, the Niobid Painter, that we first see, sometime in the 460s, a particularly important new development: the breaking up of the regular single ground level into a number of small, separate ground-lines spread up and down the surface of the vase in an attempt to add

closed; the stopper was then removed and the wine allowed to flow out, usually into a *phiale* or bowl, thereby aerating it and making it foamy. The Tarquinia Painter's sphinx, however, has no such hole and really belongs to the class of human or animal-headed drinking vessels, as does the Sotadean ram's head vase. Besides such fanciful creations, Sotades was also interested in the use of difficult techniques such as coral red, white ground and gilding. Like Nikosthenes before him, he succeeded in capturing a number of far-flung markets, for his vases were prized not only at Capua, but also on Cyprus, in Egypt, Persia and the Greek colonies on the northern coast of the Black Sea. In his painting, too, Sotades – for painter and potter are here most likely to be one and the same – endeavoured to match his

53 *Dinos* attributed to the Polygnotan Group, depicting a battle between Greeks and Amazons. Made in Athens about 440 BC. Ht 25.8cm. GR 1899.7 – 21.5.

54 Neck-*amphora* attributed to the Trophy Painter, showing Athena and Hera (?). Made in Athens about 440 BC. Ht 34.1cm. *BM Cat. Vases* E 316.

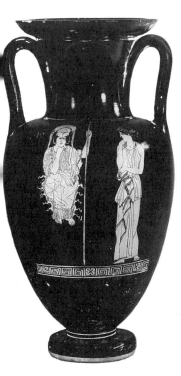

a feeling of space and depth to the picture. This scheme matches the detailed account in Pausanias' *Description of Greece*, the second-century-AD equivalent to the *Blue Guide*, of two works by the wall-painter Polygnotos in a building at Delphi. We can, therefore, reasonably assume that we are witnessing the direct borrowing by vase-painters of an idea developed in the realm of wall-painting.

Few vase-painters of this period actually adopted this new idea, but some monumental vases with single ground-lines, which show Greeks fighting Amazons and Lapiths fighting centaurs, also seem to owe their inspiration to the large-scale wall-paintings of Polygnotos and his con-temporary, Mikon. The same is true of some vase-painters of the years after the middle of the fifth century. One of these was actually called Polygnotos, quite poss-ibly named after the earlier wall-painter. He had a large number of associates and followers, and from the hand of one of these comes a fine *dinos* showing Greeks fighting Amazons. The split ground-lines do not really seem to have been thought suitable for such crowded battle scenes, but we can still see the influence of free painting in the rocky base-line.

The setting of figures up and down the vase occurs more often in quiet scenes where the aim is not violent action but the evocation of mood prior to or following on from such events. On a small neck-*amphora*, by an artist known as the Trophy Painter, we see Athena seated high on a hillock, facing straight towards us, her chin resting on her hand, deep in thought. Beside her stands a woman who echoes this gloomy mood and pose. Martin Robertson, who has done much to reveal the connections between vase-painting and free painting, has suggested that this woman is Hera and that the two rejected goddesses are now contemplating the sack of Troy that has followed upon their loss in the beauty competition adjudged by Paris – one of Polygnotos' most famous paint-ings was called *Troy Taken*.

Once this trend for borrowing techni-ques and scenes from free painting had begun, it perhaps spelled the end of vase-painters as important and independent artists, a status which they seem to have increasingly enjoyed since the sixth cen-tury. Indeed, from the middle of the fifth century we start to see a decline in the number of painters' signatures (this was followed later by a similar decline in the number of potters' signatures, until all signatures died out early in the fourth century). Nevertheless, despite this down-ward turn, some vase-painters working on a white ground seem to have been able to adapt their technique more readily than those employing the ordinary red-figure scheme so that they at least could do more than echo the new advances being made outside their own discipline.

The most important shape to be decor-ated with a white ground proved to be the *lekythos*. This shape, which had a long history in Greek pottery, was designed to

hold sweet-smelling oil and was regularly associated with burials. It was, therefore, a suitable vessel to be given the special and probably expensive white slip. On the left of figure 55 is a white-ground *lekythos* dating to around 460 BC, which is probably the work of the Villa Giulia Painter, a follower of the cup-painter Douris. The technique used on the Brygos Painter's jug has already been modified, for the contours are no longer hard black relief lines, but golden brown dilute glaze lines. The effect has also been made more vivid by the addition of two different shades of purplish red for the woman's drapery and a thick white to give her skin a different tone from that of the background.

This 'second' white for female flesh and the rather restricted purplish range of added colours, however, seem to have proved unpopular. Furthermore, the fact that these vases were now being used almost exclusively as offerings in the tomb, and so did not have to withstand any sort of wear, meant that the painters could begin to experiment with matt colours in a wider variety of shades that would not be so permanent. The results must have been very beautiful, but all too often the added washes of colour have faded away, as on the fine piece in the centre of figure 55. This lady and her maid are the work of the Achilles Painter, who carried on the tradition of the Berlin Painter down to 440 BC and beyond. His earliest white-ground *lekythoi* used the 'second' white of the Villa Giulia Painter's piece, but he soon abandoned it in favour of the experiments made by others. On this example the matt red of the lady's bundle of clothing is still quite well preserved and one can just make out on the original that its fold lines are yellow. The wash given to the garments worn by both women has, however, completely

back cover

55 *Right* (a) *Lekythos* attributed to the Villa Giulia Painter (left), and depicting a seated woman. Made in Athens about 460 BC. Ht 35.7cm. *BM Cat. Vases* D 20. (**b**) *Lekythos* attributed to the Achilles Painter (centre): woman and her maid. Made in Athens about 440 BC. Ht 36.3cm. *BM Cat. Vases* D 48. (**c**) *Lekythos* attributed to the Reed Painter (right), showing a woman and a youth at a tomb. Made in Athens about 410 – 400 BC. Ht 31.8cm. *BM Cat. Vases* D 73.

disappeared and we are left only with the sketchy contour lines, which give the misleading effect of absolutely transparent material. We can but guess at what colour the Achilles Painter actually used – it may have been a pale yellow ochre or a greybrown, both of which can be found on some of his other works.

The Achilles Painter's women have a pure classical mood and style that match the Parthenon sculptures. They are imbued with the grace and confidence that one naturally attributes to the wives and womenfolk of rich and powerful Periklean Athens – tall, serene and beautiful, like Olympian goddesses. But the potter of the day had no such romantic ideals. For the sake of his customer's pocket he has constructed within this beautiful gift to the dead a false interior, thus turning a generously large *lekythos* into a very small offering of oil.

Experiments with matt colours on whiteground *lekythoi* continued and by the last quarter of the century matt red and black were being used for the contours of figures and other objects, while an increased palette of additional colours, including green, blue and mauve, was developed for drapery and other areas of colour. On a simple but well preserved *lekythos* by the Reed Painter, a work of the last decade of the fifth century, we find matt black contours and a brilliant green. A youth and a woman stand before a tomb: the woman decks it with woollen fillets; the youth leans on his stick. The gesture of his right hand seems to link him with the woman tending the tomb, but a comparison with similar scenes suggests that he might be the deceased. There appears, at times, to be a deliberate ambiguity in the iconography of some of these *lekythoi*, an ambiguity intended perhaps to suggest the ephem-

55c

56 *Lekythos* attributed to Group R and showing a woman seated at a tomb. Made in Athens about 410 – 400 BC. Ht 51cm. *BM Cat. Vases D 71.*

eral nature of life on earth and the ever-recurring prescence of death.

From the same workshop as the Reed Painter come a number of rather finer *lekythoi*, the 'Group R' *lekythoi*. On one of these a woman is seen seated on the step of her husband's tomb, her arms folded as she sadly contemplates her future as well as the past. Contours are here represented by short, broken lines which seem to suggest volume rather than accurately mark out its limits. This technique recalls the descriptions preserved in our literary sources of the work of the great free painter Parrhasios, who was active in Athens during the Peloponnesian War (431-404 BC). He was said to have achieved volume through line, without the use of shadow. The technique of shading (the ancient Greek term is *skiagraphia*) is associated with two other leading free painters of the late fifth century, Apollodoros and Zeuxis. Shading can be found on vases for minor objects like shields, jugs or hats as early as the beginning of the fifth century, but it is not until its close that we see it used to create the impression of volume in human figures (male only). This occurs on a small group of huge *lekythoi* that are probably all the work of one artist. Their scale suggests that they were intended to compete with the marble *lekythoi*, which had now become popular as grave-markers.

The British Museum's Group R *lekythos*, however, seems to reflect interest in one other technical device, namely perspective. One literary source attributes the invention of organised perspective (*skenographia*) to Agatharchos, a contemporary of the other free painters just mentioned, who is said to have written a treatise on a stage-set that he painted for the performance of a play by Aeschylus, probably after the poet's death. In fact, partial linear perspective (fore-

shortening) was applied in vase-paintings to both figures and objects from the end of the sixth century BC, but around the end of the fifth century there seems to have been a quickening of interest in such things on vases. On our *lekythos* the bottoms of the vases placed on the top surface of the large tomb are obscured as a result of the low viewpoint chosen for this partial perspective. This sort of low viewpoint is typical of the late fifth-century, and it is only in the fourth that they were occasionally combined with a high viewpoint. As a result, we cannot be sure that Agatharchos' treatise sought to consolidate these two angles of vision into a single horizontal plane, which would have been the real beginning of a unified system of perspective. We may, however, conclude that such questions and attempts at answers were in the air.

In following the development of the white-ground *lekythos* to the end of the century, we have ignored both red-figured vases and the more ordinary black-glazed pottery. The second half of the fifth century saw black-glazed vases become very popular: their potting was remarkably fine and the shiny black glaze a definite attraction. At this time various types of stamped and engraved ornamentation began to be used, this decoration being carried out before the application of the black slip. One of the most elaborate products of this type is a 57 fine, small mug in the British Museum. Above a ground-line made up of maeanders we see the decapitation of the Gorgon Medusa by Perseus, aided and protected by Hermes and Athena. From the neck of the Gorgon spring the winged horse Pegasus and the child Chrysaor.

In the realm of red-figure vases some artists continued the large, sober manner of the vase-painter Polygnotos and his school, but there also arose a number of painters who tended towards prettier, more delicate creatures, whether on small or larger vessels. The most famous exponent of this style was the painter who decorated a splendid *hydria* (water jar) 58 signed by Meidias as potter, a piece which was probably made during the final years of the Peloponnesian War. The body of the vase is divided into two separate zones by an ornamental border. The lower zone depicts Herakles in the garden of the Hesperides – the Hesperides ('daughters of evening'), together with a dragon, guarded a wonderful tree on which grew golden apples, the target of Herakles' final labour. The key section shows three of the Hesperides around the tree and, to the right, Herakles seated with his nephew Iolaos behind him. The mood of the scene, however, is not that of a life and death struggle for immortality, the idea behind Herakles' labour, but rather one of idyllic repose in a garden full of delights, the Elysian Fields attained, a spirit which invests most of the Meidias Painter's compositions.

The upper zone is much less frieze-like in design. The scene shows the Dioskouroi,

57 Black-glazed mug: the death of Medusa. Made in Athens about 440 – 430 BC. Ht 9.6cm. *BM Cat. Vases* G 90.

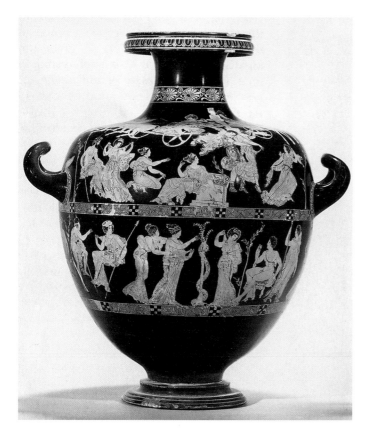

58 *Above Hydria* potted by Meidias and attributed to the Meidias Painter. The upper zone shows the rape of the daughters of Leucippus, and the lower zone Herakles in the Garden of the Hesperides. Made in Athens about 410 – 400 BC. Ht. 52.2cm. *BM Cat. Vases* E 224.

60 *Above right* 'From Sir William Hamilton's Collection': a coloured print by James Gillray, London 1801.

Castor and Polydeuces, come to steal the daughters of Leucippus. The two daughters of the king have been surprised, together with their companions, as they were gathering flowers in the sanctuary of Aphrodite. The goddess sits beside her altar at the bottom of the scene, invisible to all, while higher up is her stiff, archaic cult statue. To the left of the statue, Polydeuces has got his girl and is already speeding away in his chariot; to the right, and lower, Castor is having more difficulty.

The composition, with its chariots pulling away from the centre and the fleeing women, is boldly centrifugal. In addition to the various ground levels in the Polygnotan manner are grasses, flowers and bay trees

representing the groves of Aphrodite. The richness of the scene is further increased by the use of gilding on the cult statue and for necklaces and arm-bands, as well as the amazingly decorative quality of the painter's drawing. In the manner of the wall-painter Parrhasios, the Meidias Painter has used line to suggest volume, the fine folds of his garments enveloping and modelling the forms beneath. All is rippling, transparent drapery, coyly tilted heads covered in fluffy curls, soft fleshy limbs and extravagant gestures: technique has perhaps supplanted taste.

This *hydria* was found in Italy and it is to Italy that we will turn in the next chapter, for there new schools of vase-painters had

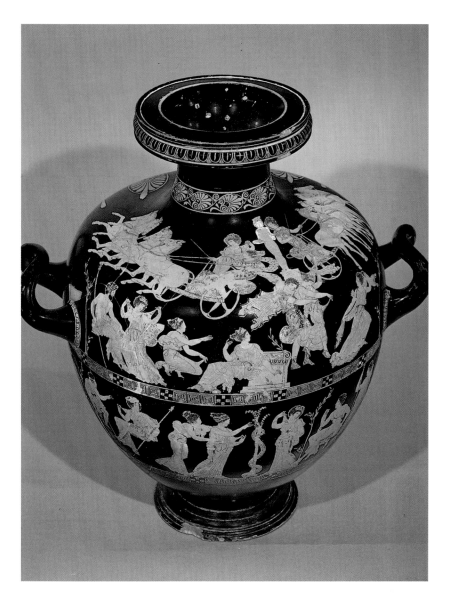

59 *Hydria* potted by Meidias and attributed to the Meidias Painter. The detail shows the rape of the daughters of Leucippus. *BM Cat. Vases* F. 224.

grown up that perhaps promised something different from the sugary gardens of the Meidias Painter. Before we leave the Meidias *hydria*, however, it is interesting to note a little of its more recent history. It was once the pride and joy of Sir William Hamilton's collection. Hamilton's ambassadorial appointment to Naples in 1764 put him in an ideal position to collect vases; this he did with a remarkable single-mindedness that won him a huge collection in just two years. But his intention was to inspire the potters and artists of his day, so he set about the full publication of his collection. In this, too, he was successful, for the master-potter Josiah Wedgwood went so far in acknowledging his debt to Hamilton as to decorate the vases especially produced on the opening of a new workshop with scenes excerpted from the Meidias *hydria* itself.

Hamilton sold his first collection to the British Museum in 1772, thereby securing the Museum's reputation as one of the most important collections of Greek vases in the world, and he then set about building up a second one. In the publication of this second collection Hamilton pioneered the idea that the vases found in southern Italy were not made by Etruscans, as most then believed, but by Greeks. It was, however, not for such contributions to scholarship that Hamilton was to be remembered, but as the husband of Admiral Nelson's lover, Emma. Cartoonists of the day spared neither the scholar nor the cuckold, as a print by James Gillray of 1801 shows: Nelson has taken on the form of the Meidias *hydria* – small foot, bulbous body, upturned handles on the shoulder, vertical handle at the back and lid (the vase was exhibited with an alien lid in the early nineteenth century). Hamilton's own passion had made him blind to that of others.

6
The Fourth Century BC

In the first half of the fifth century, as we saw, Greeks living in Italy used to place imported Athenian vases in their tombs. In the second half of the century this flow of imports began to be supplemented by vases made locally by immigrant artists. These artists perhaps accompanied the Athenian settlement of Thurii in 443 BC, but they seem to have decided to settle in the area of Metaponto further north, where some of their kilns have actually been found. One of these early South Italian vase-painters, the Pisticci Painter, decorated a bell-shaped *krater* which shows an Eros chasing a youth. The scene is the same as that on a small contemporary Athenian *pelike* (storage jar) by a minor artist known as the Hasselmann Painter, which was found in Italy. The difference in style and treatment, however, is quite noticeable: in the colonial version the Eros is earthbound and rigid and the youth's drapery is heavy and towel-like, while on the Athenian vase there is still a sprightly charm to the Eros and the youth's *himation* looks, in comparison, far more like real, warm material.

Simple subjects and rather stiff drawing are typical of the earliest products of these South Italian vase-painters. In time, however, the artists become more independent and adventurous. On a much more ambitious calyx-shaped *krater* dating from about 420-410 BC we see Odysseus and his companions set about blinding the one-eyed Cyclops, Polyphemos, as he lies in a drunken stupor. The multi-level scheme derives, of course, from the ideas of the mainland wall-painters of the 460s, which were imitated by some Athenian vase-painters. In this case, the presence of two frolicking satyrs on the right suggests that the subject of the scene is dependent on a satyr play, perhaps Euripides' *Cyclops*, which was probably first produced in Athens around 425 BC and is the only burlesque of this type to have survived from antiquity.

Some time around 430-420 BC a second workshop seems to have arisen, based perhaps at Taranto. The first major artist of this group is called the Sisyphus Painter. He painted some vases in a simple, plain manner, rather like those of the Pisticci Painter and his followers, but he also decorated some rather grander pieces. A particularly fine *krater* with volute-shaped handles from Ruvo in Apulia gives us a good idea of the Sisyphus Painter's best. A youth is saying farewell to a sceptred king, behind whom is a woman holding a *phiale* for the ritual ceremony of departure. To the right of the youth is a princely horse, eager to be off, but also showing an almost human interest in the final farewell of father and son.

From the Sisyphus Painter's work there developed two main streams of Apulian vases, as they are called, the Plain Style and the Ornate Style. The latter was perhaps encouraged by the elaborate late fifth-century Athenian vases that were imported to places like Taranto and Ruvo. Around the end of the first quarter of the fourth century (*c.* 380-370 BC) new elements were introduced to the Ornate Style, particularly in the decoration of the volute-*krater*. The artist who seems to have been responsible for this is known as the Iliupersis Painter (named after the depiction of the sack of Troy on one of his vases). His major innovation was the introduction of specifically funerary iconography to match the function of these monumental vases, which now seem to have been deliberately designed for the tomb. On a particularly elaborate volute-*krater* we see a small temple-like structure (*naiskos*) with a youth

61 *Below* (**a**) Bell-*krater* attributed to the Pisticci Painter (left), showing Eros and a youth. Made in Lucania about 440 – 430 BC. Ht 23.9cm. *BM Cat. Vases* F 39. (**b**) *Pelike* attributed to the Hasselmann Painter (right): Eros and a youth. Made in Athens about 440 – 430 BC. Ht 21cm. *BM Cat. Vases* E 397.

62 *Below, right* Calyx-*krater* attributed to the Cyclops Painter and depicting the blinding of Polyphemos by Odysseus and his crew. Made in Lucania about 420 – 410 BC. Ht 47cm. GR 1947.7 – 14.18.

63 *Right* Volute-*krater* attributed to the Sisyphus Painter, showing the departure of a youth. Made in Apulia about 410 – 400 BC. Ht 66.9cm. *BM Cat. Vases* F 158.

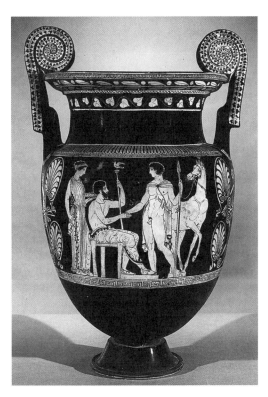

inside – a representation of a contemporary Tarentine funerary monument. Round about are gathered youths and women who have brought offerings to the tomb. Added white has been used for most of the *naiskos*, for the youth and for the laver on which he leans, sorrowfully trailing his fingers in the water and thereby disturbing the reflection of his face; this added white must be intended to represent marble or stuccoed stone. The upper part of the *naiskos* and the stool, on which the youth sits up on the right, are rendered in a sophisticated three-quarter view with a low angle of vision, an idea we have already seen on Athenian vases of the late fifth century. Here, however, the laver and the lowest step of the *naiskos* are also seen from a high viewpoint. This sort of attempt to unify viewpoints may reflect Agatharchos' treatise, or developments on it. At any rate, it is interesting to note that one of the other great free painters of the end of the

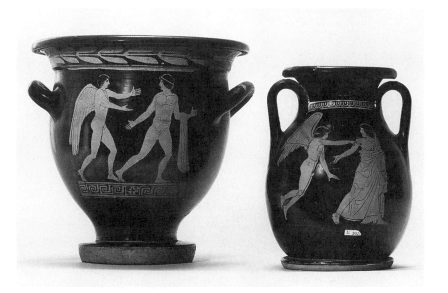

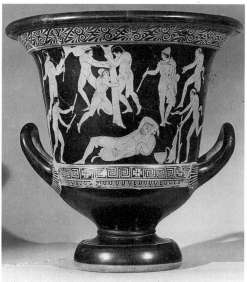

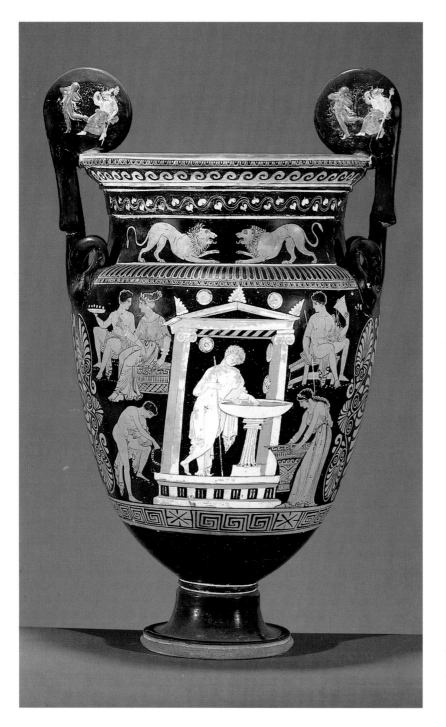

fifth century, Zeuxis, was probably a citizen of Herakleia in southern Italy.

These two schools, the Apulian based on Taranto and the Lucanian centred on Metaponto, ran parallel for some years, but the Apulian school expanded to new centres, whereas the Lucanian seems to have retreated into the hinterland in about 380 BC with the result that its products look more and more provincial. It is around this time, however, that a new school of South Italian vase-painters emerged further north, in Campania. Dale Trendall, to whom we largely owe our detailed knowledge of South Italian vase-painting, has suggested that the roots of this Campanian school lie in a small group of Athenian trained artists active in Sicily (perhaps at Syracuse) in the last quarter of the fifth century, some of whom must have actually moved to Campania around 380 BC.

An important tomb-group in the British 65 Museum, the so-called Blacas Tomb discovered in the early nineteenth century by the Duc de Blacas at Nola in Campania, belongs to the very moment of this migration. The two large *skyphoi*, which 65a,b show satyrs, maenads and nymphs in rocky settings, are by one hand, the Painter of Naples 2074, who may well have begun his career in Sicily at the very beginning of the fourth century, only to move to Campania. One of the *hydriae*, that showing a Dionysiac revel, is the name- 65d piece of the Revel Painter, one of the earliest painters to be actually trained in Campania.

The two remaining vases from this tomb, however, are slightly earlier imports from Athens and may have been the prized possessions of the deceased, to which local vases were added on his death in order to make a balancing set. The stemless cup 65c with Dionysos, Ariadne and an Eros on the

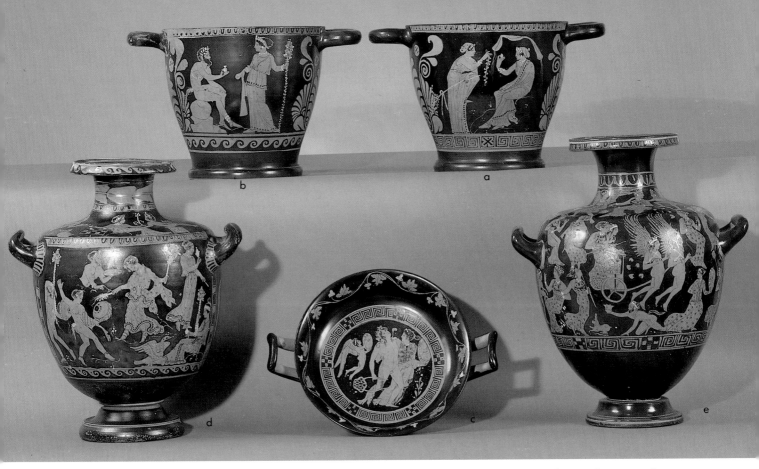

64 *Left* Volute-*krater* attributed to the Iliupersis Painter: visitors at a tomb. Made in Apulia about 380 – 370 BC. 68.8cm. *BM Cat. Vases* F 283.

65 *Above* Vases from the Blacas Tomb at Nola:

a skyphos attributed to the Painter of Naples 2074, showing two nymphs. Made in Campania about 380 – 370 BC. *BM Cat. Vases* F 129;

b skyphos attributed to the Painter of Naples 2074, showing a satyr and a maenad. Made in Campania about 380 – 370 BC. *BM Cat. Vases* F 130;

c cup attributed to the Meleager Painter: Dionysos and Ariadne. Made in Athens about 390 – 380 BC. *BM Cat. Vases* E 129;

d hydria attributed to the Revel Painter, showing a Dionysiac revel. Made in Campania about 380 – 370 BC. *BM Cat. Vases* F 156;

e hydria attributed to the Painter of London F 90, showing Aphrodite and Peitho in a chariot drawn by Erotes. Made in Athens about 390 – 380 BC. Ht 38.9cm. *BM Cat. Vases* F 90.

interior is by the Meleager Painter, an important artist who carried on the tradition of the Polygnotan group of vase-painters at Athens alongside the richer Meidian school. Gone, however, is the Polygnotan solemnity and under Meidian influence we find instead a certain sensuous ecstasy. The remaining *hydria* is by 65e an imitator of the Meleager Painter, and shows Aphrodite and Peitho (Persuasion) in a chariot drawn by Erotes. More Erotes, satyrs and maenads escort the group – an all too florid flight of fancy.

At Athens the rich style of the Meidian school had, by the second quarter of the fourth century, developed into what is now called the Kerch Style (named after a place

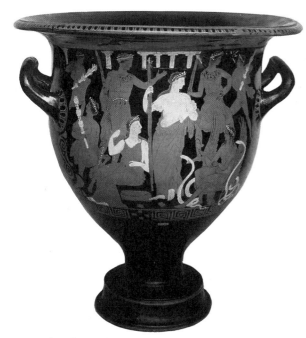

in the Crimea, on the north coast of the Black Sea, where many fourth-century Athenian vases have been found). The sugary delicacy of the Meidias Painter's own works has, however, been replaced by a sketchier, harsher treatment with a great deal of added colour, especially white, yellow and gold. A rather better than usual example of the early Kerch Style is a bell-shaped *krater* found at Santa Agata dei Goti in Campania. It dates from around 370 BC and is the work of the Pourtalès Painter (named after the former owner of this piece). The multi-level scheme is maintained in this representation of the gathering of Herakles and the Dioskouroi for their initiation into the Mysteries of Demeter and Persephone at Eleusis. In the centre are Demeter and Persephone, their flesh rendered in added white; on the right sits Triptolemos in his fabulous chair; and above stand two tall males who are probably Iakchos and Eumolpos, male associates in the Eleusinian cult. The

Dioskouroi approach from the upper corners, Herakles from the lower left. As prospective initiates they carry special rods of myrtle (*bakchoi*); the others hold torches, for it is night and the full moon shines up on the right of the columns which represent the sanctuary of Eleusis itself.

The Kerch Style seems to have reached a peak shortly before the middle of the fourth century in the work of an artist known as the Marsyas Painter. On a splendid *pelike* (storage jar) from a tomb on Rhodes we see Peleus come to carry off Thetis. There is much added colour in the manner of the Kerch Style — gold for Peleus' pointed hat and Thetis' hairband, and for parts of the wings of the hovering Eros, blue for the rest of his wings, and a green for the drapery over Thetis' knees. Added white has been used to highlight both Eros and the naked body of Thetis.

The crouching, turning pose of Thetis recalls the later sculptures of Aphrodite bathing. This twisting action, which in nature and sculpture occupies space so well, can brilliantly evoke both depth and volume even in the two dimensions of painting. Thetis' legs are in profile, although the slightly higher left thigh helps to suggest depth, as does her stomach, but it is her breasts, one virtually in profile, the other nearly frontal, and her head turned round in three-quarter view toward her attacker, that really seem to pull the figure out into the third dimension. The fleeing Nereid up in the right-hand corner of the scene is of similar pattern, but the twist follows the other direction — near-profile legs, three-quarter buttocks, frontal back and, most remarkable of all, a *profil perdu*. This Nereid's elaborate pose, and that of Thetis, are probably derived from contemporary wall-painting, although elements of them are to be found much earlier

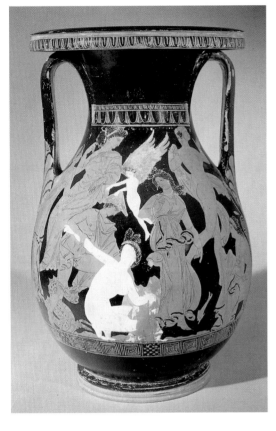

67 *Pelike* attributed to the Marsyas Painter, showing Peleus and Thetis. Made in Athens about 360–350 BC. Ht 43.3cm. *BM Cat. Vases* E 424.

69 *Above right* Calyx-krater attributed to the Laodameia Painter. Detail of decorated zones: above, an enigmatic scene; below, Perithoos and the centaurs. Made in Apulia about 350 BC. Ht 76.5cm. *BM Cat. Vases* F 272.

— even the *profil perdu* occurs on a vase by Onesimos from the very beginning of the fifth century. Finally, the drapery continues the harsher style of the Eleusinian *krater*, in contrast to the clinging, almost wet folds of the Meidian vases. Here, however, the idea of pairing the fold-lines to hint at the darkness trapped between is used with greater confidence, with the result that the drapery of these monumental Nereids seems to recall the heavy satin gowns of Hollywood.

In southern Italy the middle of the fourth century saw the Apulian Ornate Style reach its peak. One of the finest pieces of all is a large calyx-shaped *krater* from Anzi, the

name-piece of the Laodameia Painter. There are two friezes with different mythological themes. The lower frieze shows an extract from the fight between the Lapiths and the centaurs at the wedding feast of Perithoos and Deidameia (mistakenly labelled Laodameia by the painter). The upper frieze is more difficult to interpret. It shows a woman sitting, head bowed and hands grasping her knees in agitation; another woman languorously adjusts her hair, as a maidservant wields a white fan. Who these ladies are is, unfortunately, far from clear, but the painting is exceptionally fine, and one might at first think of influence from the Kerch vases of Athens: the eloquent

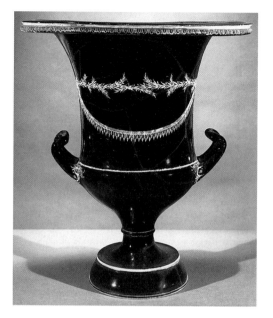

70 Calyx-*krater* decorated with a gilded myrtle wreath and necklace. Made in Athens about 340–320 BC. Ht 69.5cm. GR 1871.7–22.3.

throughout the fifth century and was, indeed, sometimes painted by leading red-figure artists of the day such as the Berlin Painter and the Achilles Painter. In the fourth century, however, there were some innovations. By 375 BC painters began to inscribe the name of the *archon* (magistrate) for the year next to the right-hand column, and around the middle of the century the figure of Athena was turned to the right, instead of the left. A perfectly preserved example bears the name of the *archon* Niketes, and so can be dated to 71 332/1 BC. The reverse shows a *pankration*, 72 an all-in fight that knew only two rules — no biting and no eye-gouging. In the centre, one athlete has caught the other's head in a tight head-lock, while he pounds the back of his neck. The scene is framed by a vigilant trainer or umpire and the next unfortunate contestant. The use of gilding and added white on Athena's drapery and the frontal and three-quarter faces of the athletes are typical of fourth-century Panathenaics and echo preferences in red-figured painting.

This Panathenaic came from a tomb at Capua, in the neighbourhood of the Brygos Tomb, and with it was found a large Athenian calyx-*krater*, all black save for a gilded ivy wreath. An almost identical vase, also from a tomb at Capua, is in the British 70 Museum, although the gilded decoration consists here of a myrtle wreath and a splendid necklace. This *krater* marks the zenith of the series of black-glazed vessels that first emerged in the sixth century BC, for it is only now that truly monumental examples and the use of gilding appear.

Later fourth-century Athenian imports to Campania such as these might suggest their possible influence on local South Italian vase-painters. Indeed, the increased

poses and the use of added colours might not be beyond their reach. The use of white dots to highlight the corners of eyes, however, and the attempts at shading and perspective from both above and below, neither of which occur on Kerch vases, suggest an increase in contact with free painting. If the best of the Kerch vases were to echo something of the work of the wall-painter and sculptor Euphranor, then the Laodameia Painter's work might reflect some of the innovations of Euphranor's successor, the wall-painter Nikias, who may have used such techniques as highlights more profusely than had been previously attempted.

In Athens, alongside the Kerch Style, there still existed the old black-figure technique, although it had been restricted, since the middle of the fifth century, to the Panathenaic *amphora*. This vessel retained its traditional shape and decoration

71 *Below right* Panathenaic prize-*amphora* depicting Athena, and *above right* (**72**) detail of reverse, showing a *pankration*. Made in Athens 332/1 BC. Ht 77.5cm. *BM Cat. Vases* B 610.

73 *Far right* Neck-*amphora* attributed to the Libation Painter and showing the departure of a warrior. Made in Campania about 350 – 325 BC. Ht 54.2cm. *BM Cat. Vases* F 197.

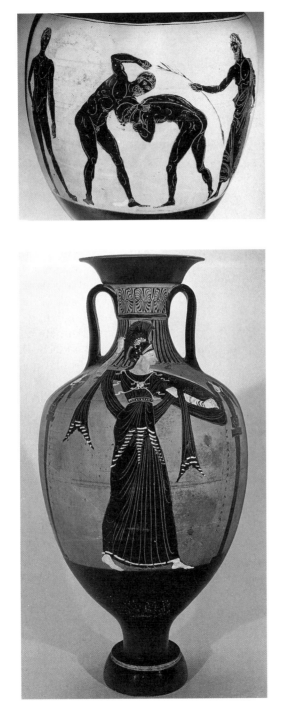

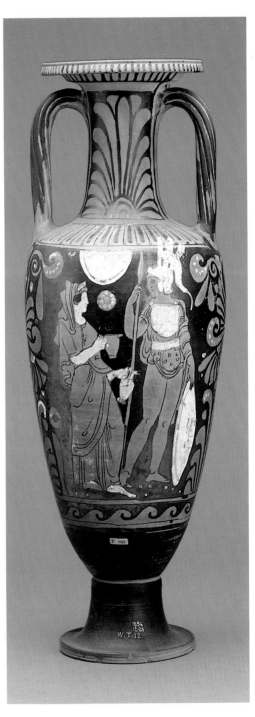

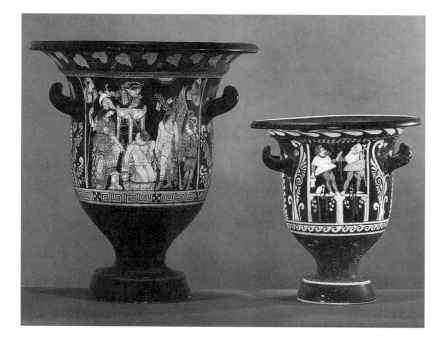

74 *Above* (**a**) Bell-*krater* attributed to the painter Python (left): Orestes at Delphi. Made at Paestum about 330 BC. Ht 56.5cm. GR 1917.12 – 10.1. (**b**) Bell-*krater* attributed to the painter Python (right), showing two comic actors. Made in Paestum about 330 BC. Ht 40cm. *BM Cat. Vases* F 189.

75 *Right* Volute-*krater* attributed to the Baltimore Painter, showing visitors at a tomb. Made in Apulia about 325 BC. Ht 88.9cm. *BM Cat. Vases* F 284.

use of added white and additional colours in the third quarter of the century could bear witness to this, but there was also a good deal of influence from the flourishing school in Apulia, whence a number of painters seem to have actually migrated. At this period there seem to have been two major centres of production within Campania, one at Capua, the other at Cumae. A tall neck-*amphora* from the Capuan school may stand as an example: a woman is offering a warrior a drink on his departure; he wears a breastplate made up of three circles, and a plumed helmet. These accoutrements are typical of native Oscan warriors, and it is possible that such vases were produced especially for the local non-Greek market.

Around the middle of the century yet another local school had developed on the border between Campania and Lucania, centred on Paestum. The origin of this school seems to have been Sicilian, as was that of the first Campanian artists. There were two main painters in the Paestan school and, unlike all other South Italian potters and painters, they have actually left us their names, Assteas and Python. Two bell-shaped *kraters* by Python give us some idea of the style. On the left the scene is set at Delphi where Orestes kneels in front of the *omphalos* (a navel-shaped cult object which at Delphi was believed to mark the centre of the earth), behind which is the Delphic tripod (the seat of Apollo's oracle). After killing his mother he had been pursued by the Furies until he came to Delphi, and he is shown here seeking refuge at the *omphalos*, his sword drawn in self-defence. One of the snake-festooned Furies appears above the tripod, the other is on the extreme right of the scene. On either side of Orestes stand Athena and Apollo, protecting him. In Aeschylus' tragedy, which seems to have influenced this work, Apollo sends Orestes to Athens, where Athena judges in his favour and transforms the Furies into the Eumenides — the 'Kindly Ones' — simultaneously establishing their cult at Athens. It is Apollo who then purifies him of his blood-guilt. Python has, however, combined the figures and action into one scene in the manner of an advertisement or synopsis, seemingly setting all at Delphi.'

The heavy figures, crowded scene and florid drawing combine to make this piece one of the most pretentious of early Paestan vases. These artists were, however, at their best when painting representations of Greek comedies and local farces, known as Phlyax plays. On the other bell-*krater* we see two comic actors in costumes and masks on an elevated stage. The scene probably depicts an old man with white hair dragging his own slave home after a

73

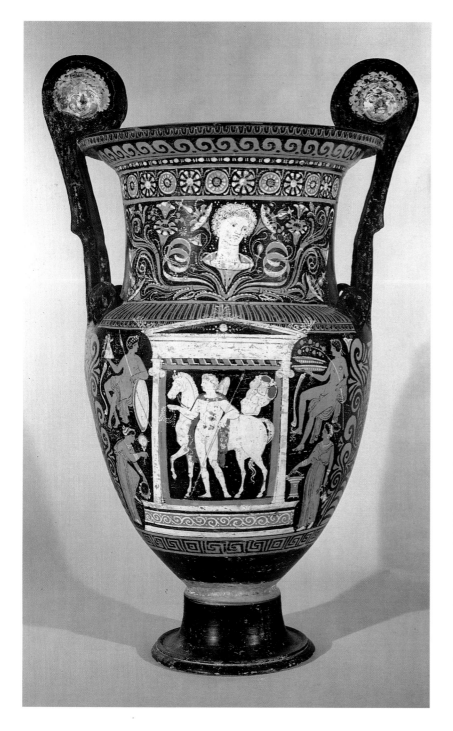

feast at which the slave has become drunk. Python has painted a colourful and vivacious picture, bringing out the irony of the affair with ease and humour.

The third quarter of the fourth century also saw the final flowering of the Apulian Ornate Style and the amalgamation of the Plain Style into the Ornate. A large volute-handled *krater* by the Baltimore Painter, 75 one of the most important Apulian painters of the last third of the century, exemplifies the full-blown late Ornate Style. A large funerary *naiskos* dominates the body of the vase, and within it are the statue of a youth and his horse, together with his breastplate. On the neck there is a female head in added white amid an elaborate spray of curling and twining flowers and tendrils. This idea, like the *naiskos*, goes back to the Iliupersis Painter (see page 56) and may be 64 considered the hallmark of developed Apulian vases. It has been suggested, however, that it has its origins in the sphere of free painting, especially the work of the panel-painter Pausias who was active in the middle of the fourth century.

The last third of the century witnessed something of a renaissance in Sicilian pottery. After the beginning of the second quarter of the century and the migration of some Sicilian potters to Campania, the production of vases on the island seems to have been very limited until about 340 BC, when political stability returned and some Campanian artists may have quit their adopted home for that of their fathers. There is little Sicilian pottery outside Sicily, but the British Museum does have a *hydria* 76 by the Lipari Painter, which dates from around 320 BC, showing two women at a *stele* (funerary marker). The maid merely holds a triangular fan, but the mistress reveals considerable emotion, raising one hand within her cloak up towards her

76 *Hydria* attributed to the Lipari Painter depicting two women at a tomb. Made on Sicily about 320 – 310 BC. Ht 33.4cm. GR 1970.6 – 19.1.

mouth, as she holds a box of eggs, an offering for the dead. Vases by the Lipari Painter often display an extensive use of added colours, and on this piece a blue can still be seen on the women's long *chitons* below the hems of their cloaks.

There is little to admire in late South Italian vase-paintings, but one final group, the so-called Gnathian pottery, is refreshingly simple and unpretentious. This style developed shortly before the middle of the fourth century, perhaps in Apulia, where it was soon produced in great quantities, but the idea was also taken up by painters in Campania, Paestum and Sicily. The technique relied on the application of added colour, usually white, yellow and red, to a black-glaze vase. A simple bottle dating from around 330 BC and from the Stockport Group gives us some idea of the freshness and charm that these vases can achieve: it shows a swan set in a floral spray that continues the tradition of Pausian florals found on the neck of the Baltimore Painter's volute-*krater*. This decoration is, however, purely ornamental and, after a few early pieces, almost no attempt was ever made to take advantage of the full possibilities of the technique.

Gnathian pottery is the only South Italian fabric that seems to have been exported in considerable numbers. This bottle was, in fact, found in Cyrenaica in North Africa, and is among the earliest of such exports. During the rest of the fourth century and the early third, Gnathian vases are also occasionally to be found in Egypt, on the Aegean islands, on Cyprus and along the coast of the Black Sea. Indeed, it seems that the markets to which the Athenians had turned in the fourth century, as exports to southern Italy became more difficult owing to the rise of the local

schools, began after the final collapse of Athenian vase-painting around 320 BC to accept Gnathian exports. The red-figured vases of southern Italy lasted a little longer, perhaps until the end of the century; Gnathian, however, was still being produced during the first quarter of the third century.

77 Gnathian bottle attributed to the Stockport Group, decorated with a swan set in a floral design. Made in Apulia about 330 BC. Ht 14cm. *BM Cat. Vases* F 582.

7

The Third and Second Centuries BC

78 *Right* Calenian *phiale* made in Campania about 300 BC, and decorated with deities in chariots. Diam. 21cm. *BM Cat. Vases* G 118.

79 *Below* Silver *phiale* probably made in southern Italy at the end of the fourth century BC, with deities in chariots. Diam. 20.6cm. *BM Cat. Silver* 8.

With the close of the fourth century came the end of the red-figure technique, but this was not the end of Greek pottery or even Greek vase-painting. We do, however, see some completely new approaches. The most radical of these, and perhaps the most damaging to the future of Greek vases, was the introduction of mould-made pottery, no doubt under the influence of vessels made from precious metals, in which the Hellenistic world was so rich. We see this first in a group of black-glaze vases made in Campania and called Calenian, after the site (Cales) at which many have been found. One group of these mould-made vases directly imitated silver *phialai*, as can be seen very clearly if one of the pottery *phialai* is set alongside a silver

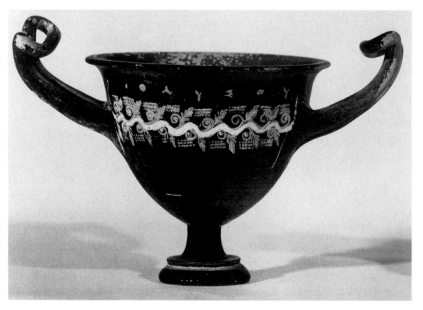

79 piece which was exported to Èze in southern France. Both have an interior frieze of four-horse chariots, each driven by a winged Victory and carrying a deity. On the silver *phiale* are Athena, Herakles, Ares, Hermes and Dionysos; on the Calenian reproduction Hermes is omitted.

Contemporary with these mould-made Campanian vases are the later works in the Gnathian style mentioned in the previous chapter. On the Greek mainland, especially at Athens, wheel-made black-glaze vases decorated with added colour carry on the tradition of the Athenian black-glaze vessels of the fourth century that were decorated with gilding. Now, however, the gilding has been replaced by simple white paint with a yellow pigment, usually built up in relief to imitate the more expensive technique. The effect can be attractive, but by the later third century the technique looks a little leaden — our example is only marginally enlivened by the word '*Diony-*
80 *sou*' ('of Dionysos') which links decoration to function.

This type of pottery, commonly called West Slope Ware after the material found on the western slope of the Acropolis at Athens, was produced from the third cenry to the first in a number of centres around the Mediterranean. Ease of communication and political groupings encouraged this tendency. One of the regions to prosper as a result of these new circumstances was Crete, where after many centuries of silence there was something of a revival in the world of pottery. Here, at the end of the third century and the beginning of the second, we see some unusually elaborate West Slope vases. One series consists of bowls with the head of Medusa moulded in relief in the centre and bright polychrome patterns around. The British Museum has a companion piece, a *hydria*-shaped jug with a Medusa head applied to the neck. 8 This head is surrounded by a very vivid and three-dimensional pattern built up of triangles of white, yellow and simple reserved clay, bounded by incised lines, and all intended to represent Athena's scaly *aegis* in which Medusa's head was set. The same combination of incision and added colour occurs in the patterns on the shoulder and the body. The perspective cubes on the body are particularly three-dimensional, but such a tectonic pattern is hardly suitable decoration for a simple pottery vessel.

In addition to this light-on-dark technique, the Hellenistic *koine* or 'common' style also produced dark-on-light pottery. Crete seems to have been the home of one of the series of such vases. These Hadra vases, as they are called (after one of the cemeteries of Alexandria in Egypt), are mostly *hydriae*, which were often used as ash-urns. From a school somewhere in the area of Pergamon, however, come a series of squat jugs

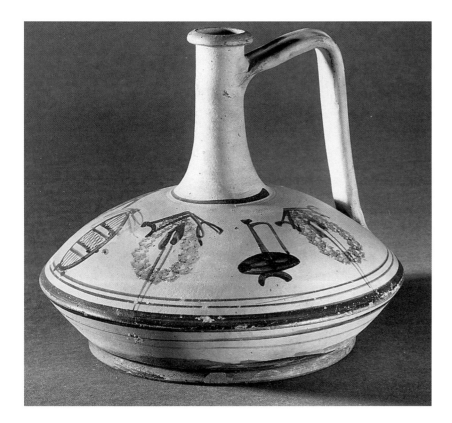

80 *Left, below* West Slope cupkantharos with floral decoration and the painted inscription *Dionysou*. Made in Athens in the late third century BC. Ht 9.7cm. GR 1908.4 – 10.8.

81 *Left, above* West Slope jug bearing a Medusa head in relief on the neck, and three-dimensional cubes on the body. Made on Crete in the early second century BC. Ht 11.1cm. *BM Cat. Vases* G 12.

82 *Above* Squat jug of the Lagynos Group, decorated with garlands, a *lagynos* and a hairnet. Made in the area of Pergamon in the second century BC. Ht 15.9cm. *BM Cat. Vases* F 513.

82 (*lagynoi*): on a thick white slip a brownish paint has been used to depict floral garlands and various objects connected with feasts - here are a silhouette representation of a *lagynos* and a fancy hairnet.

More elaborate white-ground vases with moulded additions were produced in some Mediterranean centres, including Sicily and Athens. Perhaps the most prolific of these was Canosa in Apulia, where in the third century BC it became the custom to include among the burial offerings some particularly extravagant ceramic products. 83 The shape (*askos*) seen here is of native origin, but the moulded additions and painted decoration are in a more Greek style. The fully three-dimensional attach-

ments consist of three draped Victories and the foreparts of two horses. In addition, a relief-plaque has been set on the neck of the vase, depicting a dancing maenad, and a large Medusa head in the centre of the body. About Medusa's head are painted scales and on either side of the body a winged sea-horse. Both the white slip and the richly painted decoration which employs blues, yellows and pink were added after firing, thus making them not only extremely fugitive but also remote from the regular technique of Greek vase-painting and closer to free painting.

Also from Italy, but probably made in southern Etruria and possibly of the third century, comes a remarkable piece, surely the work of a Greek artist. On the interior of a simple dish a lonely young hunter sits on a rock covered by his cloak, his spears in one hand, his head resting on the palm of the other and his dog by his feet. It is a moving composition and the use of shading and highlights is splendidly successful. This piece shows us what fourth-century wall- and panel-painting may have been like, as well as what might have been made of the Gnathian technique. The youth is, however, one of the very rare examples of a human figure painted on a vase after the end of the fourth century, and surely depends directly on some famous wall-painting.

The most commercially successful Hellenistic ware, however, was the so-called 'Megarian Bowl'. This type of mould-made deep bowl with relief decoration was produced in many centres throughout Greece and the Hellenistic world — in Athens, Corinth, the Peloponnese, the islands and the Greek cities on the coast of Asia Minor — from the third century to the first. The decoration is usually floral in character, but there are also some with figured

inside back cover

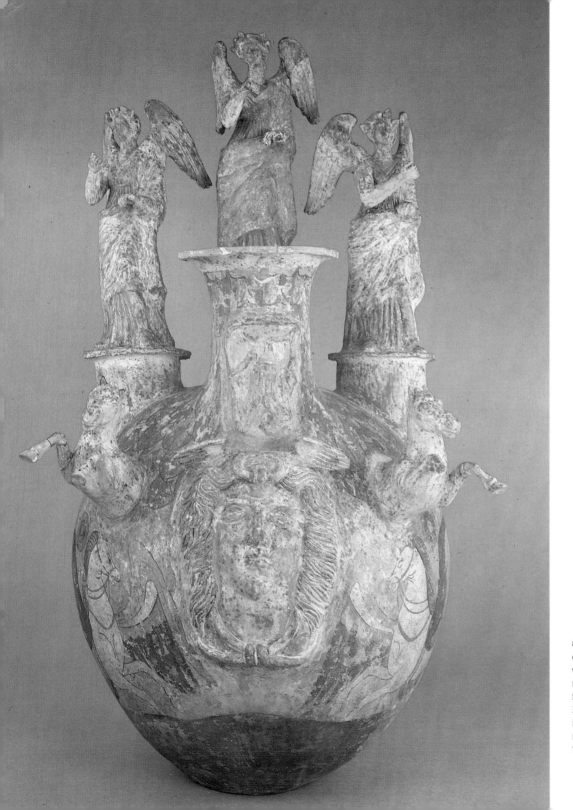

83 Canosan *askos* lavishly decorated with painted winged sea-horses and moulded figures of Victories, foreparts of horses and a Medusa head in relief. Made in Apulia in the third century BC. Ht 76.5cm. *BM Cat. Terracottas* D 185.

scenes, as on the Athenian example illustrated here, which shows Herakles seated with the naked figure of Auge on his knees (she became the mother of Telephos), flanked on either side by a figure of goat-legged Pan. The technique of production involved centring the mould on the wheel and then throwing the vase inside it, in contrast to the Calenian *phialai* which were made by pressing the clay into the mould by hand. The technique of the Megarian Bowls was taken up by Roman potters in the late first century BC, their products being known as Arretine Ware. With the beginning of the production of fine Roman pottery and its export all over Europe we come to the end of our brief survey of nearly six thousand years of pottery produced in Greece and the Greek world.

84

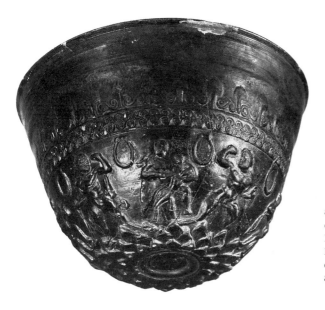

84 Megarian Bowl with relief decorations depicting Herakles and Auge flanked by Pans. Made in Athens in the early second century BC. Ht 8.6cm. *BM Cat. Vases* G 103.

Further Reading in English

P.E. ARIAS, M. HIRMER and B.B. SHEFTON, *A History of Greek Vase Painting* (London, 1962)

J.D. BEAZLEY, *Attic Red-figured Vases in American Museums* (Cambridge, Mass., 1918)

J.D. BEAZLEY, *Potter and Painter in Ancient Athens* (London, 1946)

J.D. BEAZLEY, *The Development of Attic Black-Figure* (Berkeley, Calif., 1951)

J. BOARDMAN, *Athenian Black Figure Vases* (London 1974)

J. BOARDMAN, *Athenian Red Figure Vases* (London, 1975)

J.N. COLDSTREAM, *Geometric Greece* (London, 1977)

R.M. COOK, *Greek Painted Pottery* (2nd edn, London, 1972)

V.R. d'A. DESBOROUGH, *The Greek Dark Ages* (London, 1972)

S. HOOD, *The Arts in Prehistoric Greece* (Harmondsworth, 1978)

J.V. NOBLE, *The Techniques of Painted Attic Pottery* (London, 1966)

M. ROBERTSON, *A History of Greek Art* (Cambridge, 1975)

A.D. TRENDALL, *South Italian Vase Painting* (2nd edn, London, 1976)

Index

Figure numbers appear in bold type